SECRET
SOUTHPORT

Jack Smith

AMBERLEY

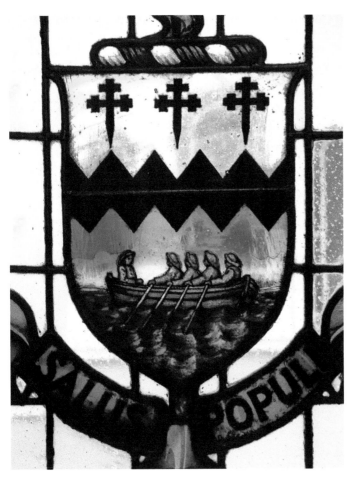

Salus populi.

First published 2017

Amberley Publishing
The Hill, Stroud
Gloucestershire, GL5 4EP

www.amberley-books.com

Copyright © Jack Smith, 2017

The right of Jack Smith to be identified as the Author
of this work has been asserted in accordance with
the Copyrights, Designs and Patents Act 1988.

ISBN 978 1 4456 6292 3 (print)
ISBN 978 1 4456 6293 0 (ebook)

British Library Cataloguing in Publication Data.
A catalogue record for this book is available from the
British Library.

Origination by Amberley Publishing.
Printed in Great Britain.

Contents

Introduction

It's hard to believe that the large town of Southport with a seemingly long-established main street, gardens, promenade, foreshore and lakes has only been here for less than 250 years. The early origins of this part of the Irish Sea coast take us back to a time when the land extended much further out into the sea from its present shoreline. This is borne out by the remains of a great forest that extended out from the shore in-between the River Ribble and River Mersey estuaries.

Later, as early man trod through the muds and sand of the seashore in his search for food, being the hunter-gatherer that he was at this time, his presence hereabout was left behind as footprints, along with the animals and birds he may have been hunting.

Perhaps these footprints should be one of our first known 'secrets' discovered relating to our Southport shoreline. From prehistoric times into the historical period, settlements were few due to the wet nature of the area, some distance inland from the shore.

Into the Roman occupation and beyond, through the Viking and Saxon periods, large settlements did not exist. The largest of these would have been Churchtown, described in early times as 'a community within the sandhills'.

The church of St Cuthbert in Churchtown is thought to have been so named following a possible 'resting place' for the monks, who had removed his remains from his burial site and taken them away to ensure they would not be destroyed by the Vikings.

Centuries later, Churchtown was still the principal village in North Meols, a village whose economy was centred on the sea, with catches of fish or shellfish being sold at local markets. The arable side of the village community took many years to become established due to the wet conditions that prevailed here. The village was quite isolated, set as it was without decent roads to get out or into it from the 'main roads' (tracks). To get to any of the major towns in the district such as Preston, Chorley, Ormskirk or Wigan was a problem – not very easy walking and uncomfortable riding on a cart.

The beach and sea had been recently 'discovered' by the visitors, who found that they could be driven the 2 miles through the surrounding sandhills to get to the beach. The landlord of the Black Bull Inn saw this transportation could make him some money and also get people to stay at his inn. This landlord's name was William 'Duke' Sutton'.

Sutton was well known for his schemes, which all seemed to lead to failure one way or the other. When the Duke's latest project was made known, a new subject was part of the local gossip pertaining to his latest folly – to build a bathing hut for visitors.

After some six years the Duke's bathing hut was in some need of repair. He decided to build an inn close to the original bathing hut in 1798. The location of the original hut was at the end of Lord Street, at its junction with Lord Street West.

The timber was purchased in Liverpool and due to arrive by boat, close to the beach where the inn was to be erected. At a celebratory party following the arrival of the wood,

one of the attendees suggested all should drink a toast to its arrival 'at this South Port in North Meols'. This name would soon became widely known, and the area was already seeing additional houses being built close to Sutton's new inn, which he called the South Port Hotel. Close by was a stream flowing into the sea, where more dwellings began to appear during the 1790s and 1800s.

The village grew between 1800 and 1850, with new buildings being added along the main street and many side streets. The first railway (from Liverpool) arrived in the village, and a Board of Commissioners was set up to oversee development in 1848. A pier was built in 1860, which later had a steamer service to Wales and all Lancashire ports. By the 1870s, the population of the new village was 18,000. During the 1880s two other railways arrived in Southport, and a fourth in 1884. This was the Cheshire Lines Extension Railway to its Lord Street terminus of which the tower and offices remain today. Southport was in the County Palatine of Lancashire until 1974, and still is geographically, but is now within the administration district of the Borough of Sefton within Merseyside. Its old motto remains the same: *'Salus populi lex supreme est,'* which means 'The welfare of the people'.

In the twenty-first century Southport has regained its attractions and added more, despite the problems with the sea's withdrawal. The additional land along the foreshore has been utilised to create the fine marine lakes and a new pier, along with the development of the Ocean Plaza Leisure and Retail complex that is alongside the road next to the beach.

The old and the new features and attractions are side by side in Southport today, with the Lord Street shops still a draw to buy or browse. Remember the shortened motto of *'Salus Populi'* meaning the 'welfare of the people' – it still applies today.

1. Forest, Footprints and Vikings

For our story about this part of the north-west coast of Lancashire, now within the Borough of Sefton, Merseyside (or to give the area its old name, North Meols), we must go back millions of years. Back to when the coastline of today looked very different. To a time when no people lived here or in the whole of Britain; to a period even before the coming of the great ice sheets that covered the entire country.

At some point several million years ago this area of the north-west had a great forest growing from the land, which today is the present sea. It would seem that the area we know today as the River Mersey Estuary was all land, perhaps with the Mersey being a river flowing through it. The evidence for this forest can still be found in some places today off the coast of Merseyside, where ancient fossilised tree stumps have been found. From the location of these stumps it is believed that this forest extended from the river estuary of the Mersey, even perhaps from the Wirral, to the south and then northwards to the River Ribble Estuary.

To research and understand the changes that took place all those years ago, as well as to include the arrival of the first humans into Britain, set against the periods of change, in geological and topographical conditions, it was necessary to allocate names to these periods. These period names have been determined along with an estimated length of time that these periods lasted.

It is thought that Britain was first covered by the ice sheets around 2 million years before present (BP). This early period was known as the Tertiary, a time when the climate is believed to have alternated between cold and warm. This period lasted until around 750,000 years BP when the first glaciation of Britain took place. A subsequent warming of the climate saw an interglacial period melting the ice sheets, causing sea levels to rise.

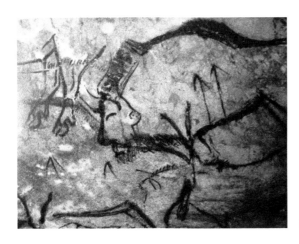

Cave painting. Hunting bison.

The Paleolithic Period

A second advance of the ice sheets to cover Britain (known as the Wolstonian Glaciation) occurred around 85,000 years BP, followed by yet another interglacial period (the Ipswichian). During this time period, humans only lived in central and southern Europe. (It would be some time yet before man arrived in Britain.) The style of living of these early humans has been identified by their 'technology', their manufacture and use of stone tools, and the famous painted images found in caves.

The post-glacial period was a time of sub-arctic temperatures, gradually warming after around 15,000 BP. It is believed to have been a time that, following the northward retreat of the ice sheets, eventually saw an increase of flora and fauna to the former land covered by the ice. The land gradually increased in area as the ice sheets melted and the frozen ground became flooded, eventually recovering enough to support plants. In turn this gradual warming saw European animals moving northward to cross the land where the English Channel is today, or via the islands and marshy banks that were covering the area where today's North Sea is.

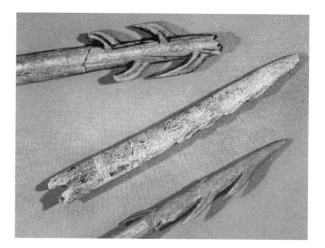

Barbed points from spears.

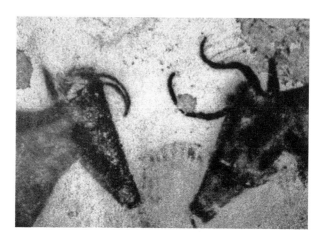

Cave painting of aurochs.

As the climate became warmer and plants and trees began to grow, the humans in the northern part of Europe followed the animals – the animals were their major source of food. And so emerged the hunter-gatherer, a title that has been given to the people who moved into Britain before the land bridge disappeared due to the English Channel being formed. We also see a vast improvement in the art of flint tool manufacture. This new culture would be called the Mesolithic period, which lasted from around 14,000 BP to approximately 5,000 BP. This is the period when we find evidence of these hunter-gatherers, who roamed the land and shore in search of food. With no huts or fixed shelters they moved constantly, sleeping in the open and always on the move in family groups. There is evidence of these Mesolithic people around the country, some of which is here in the Southport area.

We should perhaps say that fossilised forest is our first local 'secret', but, as for the people, the evidence left by them is something very special too. It proves that we really are following in the footsteps of our prehistoric hunter ancestors when we paddle in the sea, which creates a true link to the past. These early hunter-gatherers hunted aurochs, which were painted on cave walls all over Europe – several thousands of years before even the Mesolithic period.

The Mesolithic Period

The sites of Mesolithic origin have always been in the minority through the north-west area. Some flint sites have been found here, inland from the west coast, such as at Mawdesley, Formby, Ince Blundell and Little Crosby. These lowland sites were on slightly higher land than the immediate area, which was comprised of bog or marshy conditions interspersed with rivers and creeks that would flood and overrun the land after heavy rains. Some of the creeks would contain saltwater because the high tides would run quite far inland. The area contained small trees of hazel or birch where the land was drier.

Mesolithic hunting area.

Regarding the fauna that our Mesolithic people hunted, this would have been roe, red deer, the large aurochs (a large cow-like animal with curving horns), smaller prey, birds, and sea food such as fish or shellfish. The marsh and bogland seems to have been present for a considerable time, probably up to around 10,000 years BP. There are parallel situations with the prehistoric hunter-gatherers to the north of the River Ribble, a few miles north of Southport.

During the excavations to construct Preston Dock, wooden canoes and human skulls were found close to the river, although it is yet uncertain if all these are very ancient. Sharpened wooden stakes were found deep in the mud and silt of the excavation work. It is likely that there were dwellings raised above the river level.

The land from the Ribble Estuary north to the River Wyre at Fleetwood would have been similar to North Meols in prehistoric times. The hunter-gatherers were here too, as more evidence proves. In Fylde, an excavation for a bungalow's foundations revealed the bones of an animal at a depth of some feet. Archaeological excavation took place to find the skeleton was that of a complete elk. (I saw this work ongoing and even handled a few bones.)

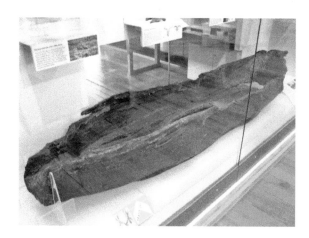

A typical hollow log canoe found locally.

Elk ribcage showing hunting injury.

The whole skeleton was removed for analysis; after cleaning, an amazing discovery was made. Not only had the animal been injured previously, as evidenced from grooving on the bones of the animal, but it had a sharpened wooden point still between the ribs (possibly aimed from a bow or by a spear). There was more to come: a short barbed spear/arrowhead was then found, still in place between the foot bones of its left back leg. It is believed it died by drowning after being injured and chased, before falling through an ice-covered mere.

The death of the animal has been put to around 13,500 BP by carbon dating. Both of the missiles found with the elk skeleton are on display in the Harris Museum, Preston. Remains of aurochs found in Preston Dock are also on display there.

This elk scenario could well have occurred anywhere along the north-west coast, and it may well have done many times over. However, many of the locations where this might have taken place are now under the sea and sand, some distance off the present shore. Excavations for the Crowlands gasworks in 1871 saw the discovery 'at a considerable depth' of animal bones thought to be 'of ancient origin'; these, too, were identified as being of aurochs.

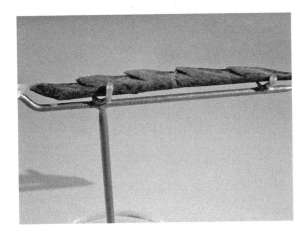

Missile point found in an elk's foot.

Mesolithic coastline.

Formby is now a southern suburb of Southport and the coast is a long, wide stretch of sandhills and sandy beach with occasional areas of former mudflats – all part of the ancient shoreline or former river estuary. The muds have been dated to prehistoric times by pollen grain analysis and modern dating techniques.

It is in some of these muds that human footprints have been – and continue to be – found. Having seen these myself (and even witnessed them emerge from the mud), I can confirm it is quite an experience. I recall being with the original researcher on this project, Mr Gordon Roberts, and seeing his meticulous and slow excavation of a human footprint. I was also close by to the discovery of multiple small footprints – children. A magical experience, and one similar to watching the elk skeleton being removed from the place it had died so long ago.

Not only have the footprints of ancient humans been found hereabouts but also those of deer and aurochs, as well as the bones and antlers of deer. These have all been found near the shore but date to the later time of around 5000 BP – now the Neolithic period, when the first settlements were becoming established. This is when the herding of large groups of animals being retained for food is believed to have started.

After meticulous research, the footprints in the Formby muds have revealed a great deal about the individuals who made them. They have not only revealed their date but also the height, length of stride, age, sex, weight, and even if they had malformations or injuries.

The prints are quite varied. What the people were doing on the ancient river estuaries, one can only speculate – most likely they were hunting! But were they strolling or perhaps, as we do today, paddling? There are single lines of individual male prints; male and female prints together, side by side; and male prints with multiple children's prints around, as if children were playing or being taught some technique. There are also animal prints and even bird prints, thought to be from a long-toed crane type of bird.

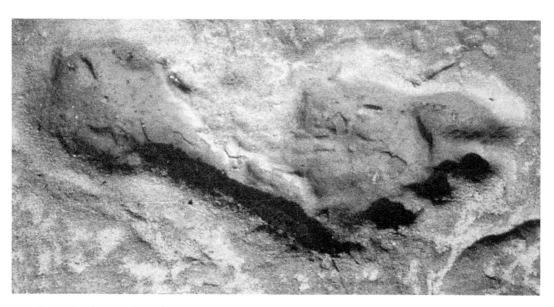

An ancient human footprint.

Flint blade.

The Neolithic Period

Our early settlers to the local area are likely to have been living during the Neolithic period, which was from around 5000 BP; the date has been proven by analysis and dating of pollen grains. The Neolithic period was a time of great change, when 'domesticity' was introduced: living in groups, herding and retention of animals, and the creation of farm-like enclosures for growing crops and the like. And they would seem to have been traders as well, perhaps even the first to start this system.

The manufacture of flint tools was at its very height in quality at this time. One such polished axe head was found locally in Little Crosby.

Dating of human footprints seems to indicate that they were made from around 6000 BP to approximately 3000 BP, effectively covering the Neolithic period and ushering into the early Bronze Age.

The Bronze Age to Iron Age

We have no positive evidence of any prehistoric community being established in the North Meols area to date, which fits with the findings from our footprint dating.

Evidence of a hut community from the late Bronze Age and early Iron Age (commencing from about I000 BP) has been found inland at Lathom, a short distance from the coast. This site is dated from around 200 BP. Four circular huts have been found together with enclosures.

The Roman Occupation

There is no evidence that there was a permanent presence of Roman soldiers in North Meols during the occupation of Britain. We can only assume and draw the parallels relating to military activities based on what we know about the early occupation of Britain after the AD 43 invasion. By the mid-first century AD the Roman army had consolidated the southern part of Britain and was moving northwards. By AD 59 Chester was consolidated as a major centre, with ships using the River Dee and the army garrisoned there planning to move to a suitable crossing point over the River Mersey. This was at Wilderspool, with the intention of creating a new road and military

A local Iron Age camp.

fort further to the north-east. It was eventually built at a place to become known as Mamucium – later Manchester.

Interestingly, Roman coins of Claudius, dating from the early part of the first century AD, have been found between the Wirrall Peninsula and along the north-west coast, up to the Solway Firth. This brings the question of how they were deposited. The most likely explanation is that the coins were lost by groups of foot soldiers during their early exploration in advance of the legion's northward movement. It is known that the Romans used a sort of 'pincer movement' to advance along a coastline. This was achieved by sending foot soldiers by boat into river estuaries to disembark and carry out their surveys, then meeting up with foot soldiers advancing overland. The north-west coast is admirably suited to this operation, evidenced by the discovery of Roman sites in or near such estuaries. No doubt there are more waiting to be discovered. Take, for example, the town of Chester (Deva): ships sailed into and along the River Dee. The River Ribble has a Roman site at Kirkham and another at Walton le Dale (near Preston), which is believed to have been a sort of supply base for goods and prefabricated wooden structures as well as iron-founding facilities. From here to Ribchester is not a great distance. The River Lune was used with a fort established at Lancaster.

The consolidation of Chester's garrison, when the earliest fort was made into the legionary fortress, was in AD 79. This date was found along with Agricola's name on a length of lead pipe. The improvement to the legionary headquarters meant that the move to the north would have been a priority in order to build a road to the River Mersey via the Wilderspool crossing point. The road would run north-east, where a new fort would be built a short way beyond the River Mersey crossing point. This place would be called Mamucium (Manchester), where a wooden fort was built. From here a road was planned to run almost due north, alongside the hills of the lower Pennines. This planned road was built and ran from Manchester to Ribchester; it was to be the military road.

Another road was created from Manchester towards Wigan in a north-west direction, which then appears to have run north from Wigan to Walton le Dale. The total length of this route is still uncertain. What was the purpose of this westerly road? The military road was via Manchester to Ribchester. The land to the west was boggy, wet and of little military value. If we join the dots, so to speak, and include a missing port, the western

road would indeed be of some use. Was the road used to access a dock on the tidal River Douglas, which runs into the River Ribble? The River Douglas was navigable and could, in early times, have allowed shallow boats upstream almost as far as Wigan.

Another aspect concerning the uncertain route of this enigmatic western road is that Roman coins have been found in Euxton and Leyland, locations that are both close to the assumed alignment of the westerly road.

Before moving away from the western road between Wigan and Walton le Dale, another thought comes to mind: did this have a branch off it, perhaps veering north-west to a ford across the River Ribble downstream of Walton le Dale and giving access to the Kirkham site. Or perhaps the road was built to Walton le Dale from Wigan during the construction of the Roman garrison there, which would originally have been built of wood with a protective fence around it. Perhaps, as Walton was a depot and supply centre, cut timber was assembled here and moved to Wigan either by road or via the Ribble and the River Douglas. There are many theories, but no firm archaeological evidence exists as of yet.

Beyond Ribchester Fort the Roman road continued to Lancaster (Galacum), where another fort was established. Then onwards via the later Lake District or Westmorland, which appears to have been less explored during Agricola's forward campaign northwards (although later sites hereabout were established of a slightly later date to the northern advance and dated to around the 80s or 90s AD, or later).

In AD 407 most of the army was removed from Britain to defend the borders of Gaul, where the Vandals had joined the fight against the Roman army.

The year AD 408 saw a massive attack by the Saxons; they had little opposition as the Roman army had effectively left the province. The attacks were defended by the British who were of Roman descent; they fought well and in many cases drove the raiders from their towns. After the raids – which were three pronged, but not co-ordinated – the country settled down for the next two years or so, then Emperor Honorius wrote to the British towns that the province was no longer part of the Roman Empire. This effectively brought to an end the occupation of Britain by Rome in AD 410.

Saxons and Other Raiders

Although the Picts, Scots and Saxons had been driven from the Romanised towns in Britain, many of the newcomers gradually settled among the British people. Some of the leaders of the Britons (such as overseers and minor officials) under the Roman occupation had stayed when the armies left. It was, it seems, down to those leaders to continue to organise and run the country for an interim time. It therefore seems that a gradual acceptance of the incoming Saxon people by the resident Romano-British took place. Village colonies were established along the southern coast shores.

Elsewhere in Britain, the Picts and Scots made inroads – as had the Saxons – not as raiders but as settlers in a new land. The Scots influx being to the west coast and Wales as far south as the River Severn Estuary.

The administration of British lands, now emerging into separate kingdoms, was undertaken with little agreements or discussion with adjacent kingdoms. This was a period often referred to as the 'Dark Ages' for we know little about the establishment of

the kingdoms, other than from the fifth-century writings of the historian Gildus, who said that 'Britain was largely under Saxon control' by that time – a situation that continued into the sixth century AD.

By the sixth century, between the midlands and north (to Hadrian's Wall, and from the Irish Sea to the Pennines) was the kingdom of Mercia. This area would later become Lancashire and Cumberland along with eastern areas (Elmet), of what would become Yorkshire. Regarding settlements from the fifth and sixth centuries within the confines of our area, they are similar to the scattering of Roman coins found in and around Sefton – scarce! No large quantities or hoards have been found, with most of the finds being single coins.

Settlements of the Anglo-Saxon people in the Sefton area, which includes Southport, have not been found. One such site, however, which we have looked at previously, emerges as one that may turn out to be a settlement. It is based on the finds of sixth-century boats in the former Martin Mere area. Previously we saw that wooden stakes had been found in the modern dried-out mere, suggesting a community raised above the water or mud of the mere itself. Although this was believed to date from the Neolithic period, could it be possible that some settlement of this part of the former mere had been used by the later Anglo-Saxons? Log-built boats have also been found upstream in the River Mersey, dating from ninth to twelfth centuries.

The Viking Period

The first raids by the Vikings (who might be of Danish, Swedish or Norwegian origin) took place to the north-east of England and north of Scotland, as well as to the Ireland's northern coast from the late 780s and into the 790s. The early raids saw their landings in East Anglia and Jarrow and Lindisfarne locations, along with raids and limited settlement in the Orkney and Shetland Islands.

Their raids continued, the middle period of which was 800 to the 830s. By this year Viking ships were exploring the east and south coast of Ireland, as well as sailing inland where they could establish settlements along the larger rivers, and the coast during the

Glass beads for necklace.

840s. The Scots, however, fought with the Norsemen on many occasions in an effort to stop their colonisation. On the English mainland, from the 840s to the 850s, many landings and corresponding battles took place against the raiders by the Anglo-Saxons, whose lands were under threat. At this time the raids on Britain increased and continued to do so; the Anglo Saxon Chronicles record that 'the raids of 865 and 871 contained many ships'.

To the west, Ireland and the Isle of Man had become well established by the Nordic people over the period AD 840 to around 900. A number also settled here on the south-west coast around Meols (the Wirral), as well as the north side of the River Mersey in what was south-west Lancashire (now Sefton).

The year AD 902 was significant one for the Norse settlers in Ireland, who were driven from their main town of Dublin by a large force. Some of those expelled made their way to the mainland north-west coast, and others to Scotland. Even though a community had been driven from the land, raiding of the Irish coast continued, and within ten years or so the Norse community of Dublin had been regained.

Over time, on our north-west mainland, another period took place when Norse people arrived peaceably as traders. The Wirral ports in Meols was an apparent favourable place for trading, as archaeological finds from that area show us. In our Sefton area, finds associated with Irish-Norse trading and movement are limited and scattered. Similarly, finds pertaining to the Anglo-Saxons are also scarce. One coin dating from AD 844 (during the reign of Athelred II) has been found in Formby. Around 10 miles from the coast in the village of Croston, close by the banks of the River Yarrow, a coin was found that has been identified as Viking, though its exact date is unknown.

The idea of a payment system originated from the area in the midlands occupied by the Norse people. Payment was given to them by the Saxons to 'offset' (reduce?) the numbers of raiding ships around the coast. Who, by and large, made their incursions ashore to pillage and loot for money or gold. This payment to the Danes was called 'Danegeld'. In 994, the money paid (to Olaf) was valued at £16,000; in 1002, it was £24,000 and in 1007, it was £36,000. This money, along with all the gold and silver – particularly of ecclesiastical items – stolen during their coastal raids was sent back to Scandinavia. Despite these payments the coastal raids continued.

During the first ten years of the new millennium (1000) we have evidence that tells us how some of the Norsemen (led by Thorkel the Tall), despite having supported the Norse system, became mercenary to the Saxons under the pay of Aethelred the Saxon king in 1012. In 1013, King Svein of Denmark arrived to become king of the Danelaw. Svein's son was Cnut (popularly called Canute), who became King of England in 1016 following Aethelred's death; Cnut ruled until 1035.

The Danegeld system was abolished and the Danelaw area became less of a no-go area for Saxon settlement. Following the Battle of Stamford Bridge, the Saxon King Harald, the King of Danelaw, removed his forces quickly to the south coast where Norman forces had landed, resulting in the famous Battle of Hastings in 1066 where Harold was killed. However this was not quite the end of the Norse/Viking period: in 1069 a fleet of Norse ships with a large force of men landed in England to help the Saxons in their battles with the Normans.

The Cuerdale Hoard

The greatest Viking hoard of coins and broken silverware – called 'hack silver' (bullion) – was found some 20 miles from the Southport coast upstream in the River Ribble, a short way past Walton le Dale at an area called Cuerdale. Here, on the bank of the river, a chest was found that was full of Viking silver items and coins. This is still the biggest Viking hoard found in Western Europe. It resides largely in the British Museum, London, although small sample collections can be seen at other museums, including the Harris Museum in Preston.

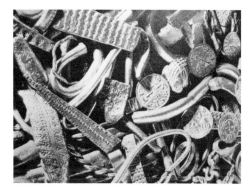

Hoard chest of hack silver.

Coin selection from the Cuerdale Hoard.

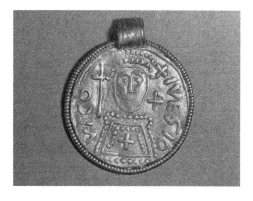

Coin pendant.

The contents of the chest weighed 88 pounds and contained a total of 7,000 silver coins, of which 1,000 were English (mainly from the reign of Alfred), 1,000 were Frankish, 5,000 were of the Danegeld and 27 were from Eastern countries.

The broken jewellery was comprised of pins, armbands, bracelets, necklaces, brooches and chains, along with many other types of crafted items for use as decoration and adornment of people, weapons, armour etc.

The burial of the chest has been attributed to the ninth century. As to why it was buried is still a point of discussion. The local theory is that it was the spoils outcome following the Battle of Brunanburh in AD 937, the mysterious and uncertain location of which is still under investigation. Many other suggestions come and go, and will continue to do so until there is more archaeological proof – perhaps it was Danegeld stolen by the mercenaries! It is more food for thought and yet another secret to be solved in the future.

Meols

The Wirral Peninsula would seem to have been the earliest settlement around the West Kirby area on the River Dee giving access to Chester. Crossing the River Mersey, it is thought some settlement may have taken place on the north side of Wirral in the Mersey Estuary. Next, moving north, we come to Great Crosby and then Little Crosby near Ince Blundell. Little Crosby is another possible settlement. Further north we arrive at Ainsdale, another site whose name may have had Norse origins. It is believed that this area extended much further out to sea (like much of the coastline locally); it is now lost due to sea changes.

At Birkdale we have two old names to contend with; the first is Argarmeols. This is believed to have been the original settlement, which, like Ainsdale, was further out to sea and so now lost. This inundation by the sea dates from after the Domesday Survey in 1086. A settlement or farmstead was extant in Argarmeols at this time as the land is listed as being in the care of Wigbert; its value was given as 8s. The settlement may have been relocated further inland and received its other name of Ravenmeols, though this is uncertain. It may be that Ravenmeols was a new and totally separate community, which could be today's Formby.

We have a few local finds of note from the time of the Norsemen, including some lone coins. The largest hoard of Norse coins found locally is from Little Crosby, which was discovered in the seventeenth century. The hoard consisted of eighty coins from AD 910, plus some pieces of silver. Sadly they were melted down, allegedly to create an ecclesiastical item (possibly a cross) for the local chapel in Little Crosby.

DID YOU KNOW?
In 1886, the greatest tragedy in the history of lifeboatmen in the British Isles occurred off the Southport coast when a ship named *Mexico* was wrecked. Three lifeboats attended. Of the boat crews from St Annes and Southport, both crews except two from the Southport boat were lost.

2. Domesday Changes and Settlements

Sometime before the invasion of the Normans, King Harold had established areas of land in the north-west between the River Mersey and the River Ribble – each with its respective value. Further north-west were lands as yet not under the control of William I. The land between the Mersey and the Ribble had previously been granted to Earl Tostig, brother of the deceased King Harold, who had given Tostig the land here for his service to the Crown. Tostig was also given additional estates of land further to the north in Lonsdale, Furness and the large area of so-called 'waste' known as Agemundrenesse (the Fylde) but lost them in 1065/66 to the Normans.

The areas of land between the rivers Ribble and Mersey were called wapentakes; separately they were Blacheburn, Lailand, Salford, Neweton, Walintune and Derbei.

Tapestry image of invasion ship.

Tapestry image of a battle scene.

Derbei (or West Derby, as it became) extended from the Mersey to the Ribble. Its taxable value in 1066 was listed as £30 16s 8d.

The Norman invaders, with William (the Conqueror) leading the army, set up an early system of rule. William's knowledge of the Anglo-Saxon kingdoms were now to become part of the new Norman Britain. Before William and his ministers could establish a system of valuation – and taxes – he needed to find out more about the land. Once the land had been valued, taxes would then be paid to the respective local overlord, which would be passed on to William's government coffers.

The setting up of such a scheme took some years to organise and involved many recorders and scribes, along with small groups of men to accompany them and ensure their co-operation and safe passage through the land. Prior to the actual recording of the areas it was necessary to determine routes to follow. This meant that a preliminary survey team was sent out to record the areas to be assessed prior to the actual tax assessment being done.

After the return of the preliminary surveyors the main recording teams were sent out sometime around 1080. Their brief was to assess all of the land, except in the far north of England, to find out who owned it, who worked it, how many plough teams were used, how many ponds or areas of wasteland there were, how many mills there were and how much forest there was. They also needed to know the value of the land at the time of the Conquest in 1066, and in 1086, which is when the assessment (known as the Domesday Survey) was compiled.

In addition to the questions for the survey there would be questions to ask the local lords: how it became their land, how long they have held it, who worked the land and was it subtenanted – if so, at what rent and for how long. These were more or less straightforward questions to ask and record, but the measuring was something else entirely.

To understand the system a little background information is necessary. Firstly, the areas of land to be assessed were called wapentakes (or hundreds). Between the River Mersey and River Ribble there were 6 wapentakes, as named previously.

DID YOU KNOW?
Shrimping and cockling was another of the allied trades of the fishing communities, and a great delicacy. 'Southport Potted Shrimps' were in great demand locally and by distant towns.

The word 'wapentake' was a corruption of 'weapons take', a name relating back to a time when weapons were brandished at gatherings and held aloft to be counted, or taken to obtain the total number of those brandished. Thus, obtaining the count of persons holding the weapons as a head count or as a system of voting.

So far as the survey work goes, the system involved was one that required the lands of any estate to be first divided up into smaller plots. These were called 'berewicks' and were worked by 'freemen, thanes or drengs' (all three names referred to the same task) who paid 2s a year in rent. One of the wapentakes was West Derby. This was the area enclosing the old part of North Meols, where Southport would later be created. There were 65 thanes in this large area.

Now we move into the realm of bovates, oxgangs and hides – the terms used in the measurement of land areas. Firstly, tenants rented their parcel of land – this was called a berewick. Each berewick had to be divided into two or three parts, which were called carucates. Each carucate was equal to 8 bovates (or oxgangs), which was equal to an area that could be ploughed by oxen per year.

At the time of the survey much of south Lancashire was woodland with lots of 'waste'. The term 'waste' was land that was neither not under the plough, nor suitable for cultivation or grazing.

The Derbei wapentake featured highly along with the wapentake of Agemundreness, where the Fylde is today. All of the land between the rivers Ribble and Mersey (plus the wapentakes of Furness, Cartmel and Lonsdale) were given to Roger of Poitou by William I for his support in the taking of Britain by the Normans. Roger chose to build his castle in Lancaster, which was a good central place to access and guard his lands.

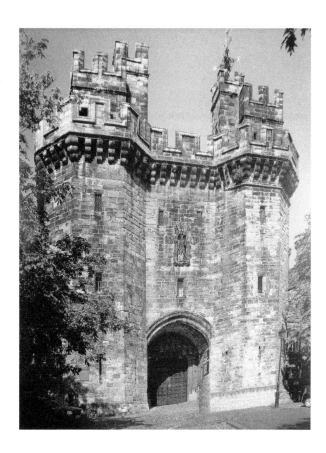

Lancaster Castle's gates.

For the entire area of land between the rivers Mersey and Ribble at the time of the Survey, the population has been estimated as having been around 10,000 persons living in isolated and scattered settlements – there were no towns.

Towards the end of the twelfth century we have a firm reference to Churchtown and the first named persons living there. We have, of course, had the names of various Norsemen throughout the area in earlier times but here we have proof of some occupation of this isolated and so-called 'largely waste' area in Norman times.

By the 1190s North Meols came under the keeping of Richard, son of Huctred, as part of the Barony of Penwortham. The deed, or grant, created for this 'keeping' mentions some of the topographical aspects within North Meols at that time. But while many features are mentioned in the charter this does not mean that they existed, all it shows us is that the said Richard 'had the right to' (create or build) something; for example, quoted in the document are woods, ways, paths, churches, mills, viveries, fisheries, meres, marshes and pools. Richard paid 5 marks and one hunting boot for this grant of land.

Some of the above mentioned in the grant may well have existed at the time. As the area is so large it makes it difficult to be specific about places mentioned, something that is not helped by the changes to land uses and development from the intervening years to modern times. Archaeological work has been carried out on some sites, such as the accidental find close to Meols Hall and the discovery of the old riverbed that flowed through the village to the sea. Timber found suggests a possible docking area here, which may have been used centuries before when the river was visible (the river may have preceded the route of the boating lake in today's Botanic Gardens).

DID YOU KNOW?
The Southport Winter Gardens Palmhouse building, where Morrisons is today, was the first of its kind to be built at a seaside resort. It was even bigger than the famous London Kew Gardens.

The movement of St Cuthbert's remains from Lindisfarne, after his seventh-century burial, was occasioned by the pagan Viking raiders' threat to remove his body. The monks moved his remains with them and may have stayed in this area for a time, which has led to the church being called St Cuthberts. St Cuthbert was eventually reburied in Durham.

Another early church was sited at Little Crosby around 1275 AD, which suggests that the two churches were sited within existing settlements at the time and the distance between them – Churchtown and Halkirk in Little Crosby – was likely to have been comprised of isolated communities.

By the end of the twelfth century the county of Lancashire had become divided among the emerging elite families by way of Richard I's accession to the throne in 1189 when the 'Honour of Lancashire' was given to his brother John, who reaffirmed privileges lost to Preston and Lancaster and raised a new charter to the emerging town of Liverpool. To his

supporters he sold off parcels of land, giving the 'freeholders' in the county access to the royal forests.

The evidence of a hall in North Meols during the twelfth century tells us a lord came to live there. It is recorded that a family named 'Meols' were the first of the local overlords – later to become 'de Meols'. Here, again, we have the uncertainty between the Wirral (Meols) and Churchtown (North Meols).

The assumption the Moels family was in Churchtown is probably correct as we learn that they were succeeded by the Coudry family, said to be of direct Norman descent. In the early thirteenth century, a Robert de Coudrey became Lord of the Manor of North Meols and carried out many 'good works' for the growing villages of the area. It has also been mooted that he may have been the person who built a hall in North Meols within the barony of Penwortham.

This was a period when many documents were produced by courts, lords of the manor, the Church and other authorities. Many of these records survive today, such as grants, charters, sales, rentals, assize rolls, court proceedings and wills. They were usually written in Latin, French or Old English. Although we get an overview of life at the time the document was made, some of the circumstances after court rulings are strange to us. But the names of persons associated with the documents are named. Even family of lords of the manor are to be found in some court rolls for 'mis-behaving'; such as Alan de Coudrey, who was fined 3d for stealing 'brushwood' during the early 1300s. William de Meols was fined 5d for holding a debt. He also featured in the records from March 1324, along with his wife, for the brewing of poor standard ale and was fined 6d.

Our William de Coudrey was a character, it seems. His marriage to Joan brought singular control of the lands of North Meols under one family. They had six sons, one of which, Robert, inherited the estate in 1340. But sadness was to overtake the area, as well as the lord and his family, when the terrible plague caused by rats – the Black Death – arose in North Meols in 1348.

It has been said that the outbreak of this devastating disease within such communities, whose knowledge of cleanliness or hygiene was minimal to zero, must have been something they were unable to comprehend. It is believed that the outbreak of the Black Death here in North Meols was one of the earliest – if not the first – to occur in the whole of the country. Many thousands of people fell victim to it; in the whole county of Lancashire, some 13,000 people had died by 1350.

The village and surrounding area changed with gradual improvements to drainage and roads (which at best were only good in dry conditions). This allowed more movement of people and the transport of more produce in and out of the village, which led to more trading and an increase in the availability of farm produce.

During the sixteenth century the first maps of the county of Lancashire were being drawn up, which gives us the first glimpse of how the county – specifically the area adjoining sea coast – was at this time. Saxton's Map of Lancashire in 1577 shows us that there was a small 'ville' called Meols (probably Churchtown), sandwiched due west of the large inland expanse of water and marsh that was Martin Mere with its islands, and the sea. South of Meols there is a long strip along the coast that is blank until we come to Formby on the north side of the River Alt. Slightly more inland, the places mentioned

are Scarisbrick, Hallsall, Barton and Alker Chapel. South of the River Alt, where Sefton is shown, we next come to Crosby at the entrance to the River Mersey.

While we must allow some leeway for the accuracy of the 1577 map with regard to scale, distances and correct locations of places because surveying techniques were a lot more basic in the sixteenth century than they are today. No roads are shown, yet the map illustrates that even then development and change was happening throughout the county of Lancashire.

It appears that the remoteness and comparative isolation of the Meols area was still as prevalent in the late 1500s as it had been during earlier times for, despite some improvements to roads and within the local community, the topography of the 'ville' of Meols – between sandhills to the west and flat reclaimed marshland to the east – was unchanged, and not really a place to go out of one's way to visit. It is of interest to note that no chapel is shown at Meols, yet one is shown at Alker to the south. A subsequent map of note – Speed's map of 1610 – shows little change from Saxton's edition, although the sandhills along the shore seem to be highlighted by Saxton. Meols is still enclosed within the extensive sandhills on it.

Despite improvement to drainage systems that had begun from around the twelfth century (which, to a large extent, were successful for limited periods only) the meres and marshland areas were easily overcome during heavy rains. Over the centuries, with so many areas of Meols being wet and boggy, many mossland areas were established. Over time these mosses became peat and were dug out, dried and used for burning. Many of the mossland areas remaining today in west Lancashire and Merseyside are now drained and have become superior agricultural areas, but their names remain.

Some deeds, grants and charters from the sixteenth century refer to mills being set up at Crossens, likely to have been early post windmills. Other mill sites are uncertain and any of these being water mills is doubtful due to the lack of fall of any stream in Meols. However, there was a post windmill here, as well as at Formby and Ainsdale. One cannot help but wonder if the corn ground at these mills was largely the property of the local lord and, if so, would it be kept to sell to his tenants or would it be sold outside the community, perhaps at a distant market?

Another major point to consider pertaining to the increase in population and cottages was that timber would have had to be moved some distance over roads in poor condition! There were no quarries from which to extract stone either – early bricks were handmade with mud and straw. And where did the wood come from that allowed houses to be built in villages prior to the sixteenth century? Bear in mind that forests were the property of the king, who allowed only the local lords to use them and not the poor villein or surf. The houses of poor workers were mainly of the 'cruck' type – mud walls between the timbers, with a thatched roof covering.

Small cottages with their thatched roofs can be seen in Birkdale and Churchtown today, being of similar construction to the early cottages. They are often termed 'fisherman's cottages' but this is not strictly true: in the past this type of house was where the estate workers lived. The 'fisherman' name was applied later because they only earned a subsistence living and could only afford a small cottage home to work from. Some of their huts may well have been the very first to be built close to the beach amid sandhills by the rivers Nile and Alt, before the beach was 'discovered'.

The lord of the manor would have lived in a timber-framed house, which would later have been rebuilt in brick or stone. Such a brick-built manor house can be seen at Meols Hall, a building that may well have had its origins back in the Saxon era. The location of the original hall has been a cause of some dispute among historians over the years for, although we have references in documents going back many centuries, the ancient building's location has not been proven archaeologically. It is assumed that the site of the present-day Meols Hall may be on the original site of a Saxon dwelling. If so, the hall would then have been just a short distance from a river prone to high-tide inundations of land. Perhaps it's a task for *Time Team*.

Another interesting point to consider, if the original hall is indeed below the present site: from the early archaeological excavation close to the gates of the present hall, a wooden structure was found with pointed stakes holding it up, likely to have been a docking place for boats to the sea. We also have mentioned here that one of the lords from the hall liked to sail – perhaps this was his dock. Another suggestion could be that the dock was one used by customs men involved with preventing smuggling activities, which was a part of life here during the sixteenth to eighteenth centuries. Smuggling was especially active along the beach due to its shallow water for beaching boats. A deep water area offshore called Fairclough's Lake was used by ships to anchor en route to larger ports. It was from these ships at anchor that many of the smuggling thefts were carried out. All of the records pertaining to these smuggling activities are contained in the court records originating from the quarter sessions held in Ormskirk. Some of these records make interesting reading, as we shall see.

We find that in 1677 a customs officer was following illicit activities on the local beaches in the area of North Meols. These activities were often based on ships at anchor off the beach. Customs men had routinely visited ships to check their manifests and cargo, and were treated badly and verbally abused by the ship's company. Some of the crew were involved in theft of legitimate cargo and offloading it from the ship to the shore – unbeknown to the non-smugglers aboard – to be collected on the beach. Spirits seem to have been the most popular items to be offloaded and smuggled ashore.

Some aspects of the smuggling stories are long-winded and use legal jargon; even some of the terminology and descriptions require a search of the dictionary to understand the reports. In the 1730s thefts of '60 pounds of tea', or of 'eight half-anchors of Brandy' are quoted. Wine was another commodity popular for the smugglers to remove and sell on. Bribes were offered to the customs men to turn a blind eye to what they had discovered, such as a share in the smugglers' earnings, or cattle or horses.

But the smuggling activities had less obvious features for customs men to find. One of these features is masked by the jargon of the so-called 'sighting lines or shore features' used by ships to navigate the shifting channels to enter the deepwater anchorage called Fairclough's Lake. Close by this anchoring location, a building was used as a 'cottage manufactury' to process sugar cane. That building was owned by companies having vessels used in the slave trade. The building was used to avoid entering the main ports where the ship and company would be known as a slave ship, due to its cargo of cane. By offloading at Meols this avoided problems concerning that trade arising later in the ship's final docking port.

By and large, the vessels using deepwater channels for temporary anchorage were on legitimate business. Yet to navigate these hazardous channels into the estuaries was problem enough during daylight hours, and even worse in the dark. This was largely due to the changing sandbanks that were constantly altering their size and location, a feature of the dangerous shore here off the coast of Meols. These shifting sandbanks were a great hazard to ships making their way to the Ribble Estuary and then inland to Preston, or entering the Mersey Estuary en route to Liverpool. These hazards were made all the more dangerous if the ships met stormy conditions when entering the channels of either river estuaries. Many unfortunate incidents at the coast hereabouts were recorded over the years of ships being lost due to running aground and breaking up.

Some ships that ran aground were wrecked with loss of life; some were beached and later their cargo was removed depending on what it was. On other occasions a speedy removal of the ship's cargo took place mysteriously during the night – despite the customs men.

In 1749 a ship called the *St George*, which was engaged in the slave trade, was making its outward run to Africa then across the Atlantic to the West Indies with its cargo. As it was approaching the Mersey Estuary – homeward bound – it met with stormy conditions. Running aground on a sandbank, the ship was broken by heavy seas and the whole ship's crew were lost on 18 October 1749. The captain of this ship was a John Grayson, aged forty-two, who is buried in St Cuthbert's churchyard.

Also buried here is a young man named Tom Rimmer. He went to sea as a boy and was held captive in some foreign location for sixteen years. When he finally returned home he discovered he'd been thought dead many years before. He was buried on 6 January 1713. Further research in the parish registers reveal that the burials of many drowned seamen and/or men associated with the sea – such as fishermen, shrimpers and the like – are also mentioned as buried here in the churchyard.

Inland from the village, within Meols Manor, during the mid-eighteenth century farming and agriculture were developing after further improvements to drainage systems and the rental of plots of additional land from the manor estates. Various animals were kept on the site, such as cattle, sheep and pigs. Crops of vegetables and corn were grown. A small amount of flax was grown, most likely to supplement the local wool that was used by the village spinners and weavers in the manufacture of clothes, which could be sold to visitors and/or at village markets.

Hand-operated wooden weaving looms were introduced here during the early 1790s, and it is of interest to note that sources refer to them as being for cotton weaving. This would mean raw, imported cotton would have to come from Liverpool. Woven wool, or a mix of flax and wool, was probably the more common weaver's product. It is recorded that the spinners of the village in the 1790s produced a 'coarse yarn for the use by the sailmakers and fishermen'.

The focal point and main building within the village was the Church of St Cuthbert. Associated with the church, a day was set aside to be called St Cuthbert's Day when a fair and market was held annually. This event saw much celebration. Visitors came to the village to enjoy the celebrations, sample the delights of local ales and look into the growing fascination of bathing in the sea, which it was mooted should be a part of the

annual fair activities. This proposal seems to have been favoured and it was decided that a 'Big Bathing Day' would be a part of future fairs.

The growing village had two inns in the 1780s. There were thatched cottages in a community that had the lord of the manor living close by at Meols Hall. A windmill might have been busy grinding corn, and horses and carts were in the streets carrying various goods and agricultural items. By this time people were arriving in the village by horse or coach. They were happy to stroll around and sample the home-made provisions available or sample the local ales, but underlying this was the fact they wanted to do and see more.

The landlord of the Black Bull Inn, William 'Duke' Sutton, heard many snippets of conversation relating to what the visitors wanted, and one of those was to access the beach to 'sample the delights of saltwater bathing'. The provision of what his clients were talking about stirred him to visit the beach to note tidal situations and high-tide limits. He also wanted to find the most suitable area; somewhere that he would help the visitors achieve what they wanted, as well perhaps to earn a little profit for himself. He was prompted also by the establishing a 'Big Bathing Day' after the St Cuthbert's fair and market day – perhaps to be followed by a 'Little Bathing Day' a week later. His notes were used to work out exactly what he wanted to do on the beach, where there was no shelter facility or place to sit and enjoy a drink or to dress again after sea bathing. It was to this that 'the Duke' wished to change.

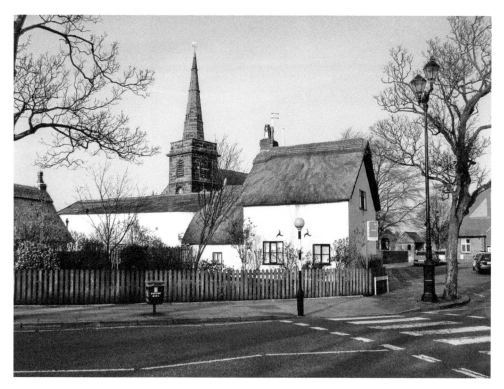

View of Churchtown.

3. A Folly and a South Port

As gleaned from various reports and writings of the time, William Sutton was a bit of a character. He played a violin at one time and was known as 'the Duke', thus William 'Duke' Sutton. (His nickname was given due to him having once met/entertained a Duke.)

From the many writings pertaining to Sutton and his businesses, we can establish that he knew the village and its people well, as we would expect a landlord of any village pub of today. He would likely know about the business of the local fishermen and farmers from whom he might purchase foodstuff for the inn's kitchen to sell along with his ales. He would have been a good conversationalist as well as a good listener, and would always be on the look out to improve his business. There was also something of a modern 'entrepreneur' about him, having an eye to the future for his business.

We have varied references to Sutton's capabilities. He was a man who liked to keep a 'finger on the pulse', so to speak, as to what was going on within the community. He had chats with local people on a daily basis, paying particular attention to stories from the

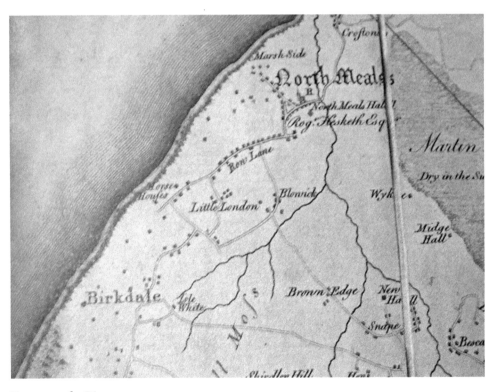

Yates map of 1786.

fishermen who said the following about visitors to the beach: 'they ran into the sea after their play to cool themselves down wearing little or no clothes'. They also spoke of times when the men who were shrimping or shellfish collecting walked in the sea with nothing on their feet to 'feel' for cockles. From these tales across the bar top, together with his own notes about the tides, a positive idea was born, which the 'Duke' was determined to look into.

In the late 1780s Sutton made notes of tidal conditions over the season, including where it came up to at various locations along the beach and where would be a suitable place to create his idea. He would often climb the sandhills to make observations and notes, and was regularly seen and acknowledged by fishermen, who thought him a little mad. Stories about him got back to the village and to Sutton himself, who laughed off the comments, which generally referred to 'some folly or other' he was looking into.

DID YOU KNOW?
A scheme to build a tram route from Southport to Lytham across the River Ribble was proposed in the 1880s. The tram, with its passengers inside, would be carried from an overhead gantry using a transporter bridge.

One day Sutton visited the beach to ask the men where the materials to build their huts and mooring places had come from, knowing there was little woodland to be found locally, at least none from which stout timbers as well as planks could be obtained. Sutton also knew that no cartloads of timber had been seen moving through the village. Yet he was standing close to many crudely built wooden huts, which at least gave some shelter to the fishermen if required. Sutton saw a need to create his idea a little nearer to Churchtown, which would help it succeed.

He was told the fishermen had searched along the shore looking for floating or washed-up pieces of wood from ships that had been grounded and wrecked. Sutton was shown a stockpile of various sized timbers, which were to be used for future jobs by the fishermen if required. Some of these could be used for beams or wall studding. There were many pieces of wood of different shapes, sizes and thicknesses, all gathered from the sea – costing nothing. The huts had a miscellany of roof coverings: from sail canvas, to planks with clay-sealed joints between.

Returning to Churchtown, Sutton was now sure that his idea would be successful following its implementation. His first task was to co-opt the services of a local carpenter, to whom Sutton outlined his scheme, along with a group of friends who were in favour of Sutton's idea. Together they went to see the fishermen and Sutton explained he wanted to purchase the timber pile the fishermen had collected to make a hut with a good roof, well-sealed from the weather, above the high-tide line close by the sandhills. A short distance away from the fishermen's huts, above high-tide level, his idea would be built at a place called South Hawes.

The place selected was close to a small river that ran into the sea (later to be named 'the Nile'), making the choice of location even better due to having a fresh water supply close by. The timber was subsequently moved to where Sutton had decided his hut would be built, and, along with his carpenter and friends, began the work of constructing the so-called 'Duke's Folly' at the southern end of today's Lord Street.

Before building started, Sutton gathered the men around the site and said what his idea would be, for he had overheard many conjectural opinions as to what he was to build. He explained that he had observed that more visitors came to the village for the celebrations on St Cuthbert's Day, as well as on weekdays during the warmer weather. He had heard in the inn how some of the visitors had gone through the village via the sandhills to the beach, and that they had walked in the sea – some even bathed in it! Having visited the larger town of Ormskirk on its market day, Sutton found out that this walking and/or immersion in the sea seemed to be a pastime that was on the increase. His idea was that they should provide a facility for those who wanted to bathe or walk in the sea, perhaps to be followed by building an inn or hotel if the 'beach hut' idea was successful.

His workforce, despite expressing surprise at the proposals, were keen for it to succeed and set to work sorting the timbers and levelling the site where the building was to be. The building was to become a changing hut for the people who wanted to bathe in the sea, and would have separate rooms for men and women plus limited other facilities for their comfort and privacy. As work on building the hut progressed, Duke was already planning future buildings in case this first one was successful.

As to if Duke's folly was a success is legend; the hut was well used during its first season of 1792, being advertised as an additional attraction for the visitors. Coaches were laid on to transport visitors through the sandhills, and the whole of his idea proved to be even more of a success than the Duke had envisaged. To ensure his visitors were provided with drinks, some of his ales, chairs and tables were moved from the Black Bull to the beach hut.

As the villagers realised that Duke's hut was certainly not the folly they had envisaged, they too visited this new and novel bathing hut, perhaps even to walk in the sea along with as the visitors. News of the venture spread and large numbers of visitors came to sample this new local phenomenon, which continued increasing in popularity for some years.

The manorial lord had no objections to the bathing hut as it was on the beach, on land unfit for arable purpose. William 'Duke' Sutton met with him to agree the hut's use in colder times of the year when it was no longer used by visitors; it was decided to be used by shooting parties.

Some years later another situation arose that alarmed the 'Duke' relating to his intention to create an inn or hotel close to the site of his bathing hut at South Hawes (approximately where today's Duke Street is, at the south end of Lord Street). He learned that a lady was to build a house, which later became a hotel for visitors, close to his existing bathing hut. He immediately leased 6 acres of land around the site of the bathing hut to ensure the land was his to use further – an area in which he would subsequently see his second idea fulfilled.

This second project was brought forwards due to a storm in 1797, which severely damaged the bathing hut. At this point, although affecting temporary repairs to the hut

as yet out of season, he drafted in his workers once again to build a new inn/hotel a little further inland from the current hut.

Knowing he could use some of the timbers from the old hut, he realised he would still be short of some, despite building the new inn/hotel with bricks. Sutton visited Liverpool to order the timber he wanted. This would be transported to the beach location close to South Hawes, where the inn would be built. It was during this time when it became known that a canal would be built from Liverpool towards Wigan to pass a few miles from North Meols.

Duke's second building was of a much grander scale in size, as well as being built from bricks. It was a little more inland than the bathing hut facility, which was still in use, even as the new hotel building work started. The reason the new hotel was to be built wholly of brick, without timber wall studding, was considered to be less likely to be damaged by storms or high tides.

It is recorded (in several sources) that the following events took place after the arrival of the timber-laden ship from Liverpool. The ship anchored in the channel known as Fairclough's Lake. This prompted a celebration among Sutton and his workers as, with the arrival of the shipload of timber, the building work could progress to raise the building higher to roof height. It is not recorded if the ship was unloaded prior to the celebration taking place. It is, however, recorded that someone in the gathering referred to the arrival of the ship with its timber at a 'South Port within North Meols'.

During the course of the evening, as more of the villagers arrived to see the latest 'folly' progress (as well as join in with the celebrations), the rumour that had bantered around earlier in the afternoon of the ship arriving at a 'South Port' was raised once again to the gathering. One of the attendees was a doctor named Miles Barton, who first called attention to the celebrating villagers. He then proceeded to pour a bottle of wine around the walls of the old bathing hut, saying the place should be called 'South Port'. The name was now duly accepted and christened.

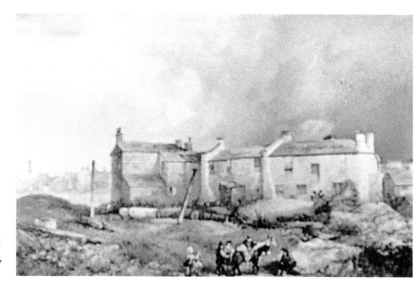

Painting of the first hotel in South Port, by Hardman.

Todays Dukes Folly hotel in Duke Street.

Progress on the new building continued. It was completed in 1798 when William 'Duke' Sutton moved in, leaving a daughter to run the Black Bull in Churchtown. The new hotel was named The South Port Hotel. It had a few name changes later, becoming the Royal Hotel and even The Duke's Folly for a while.

The river (Nile) area was attracting more attention from visitors and locals alike, and other building plots were being considered close to the river. Improvements to the old access road through the sandhills from Churchtown were proposed, which would later become Lords Street.

The cottage of a Mrs Walmesley was built (called Belle Vue Cottage) directly across the river from the South Port Hotel. The cottage would be for private use only. The following year the doctor who had christened the name South Port, Dr Miles Barton, also built a cottage here, which he called Nile Cottage. This was located close to the estuary of the River Nile, close to the beach.

The Duke was credited as being the founder of the new South Port community. He certainly built the area's first bathing hut and then hotel in 1798, which puts him as the founding father of the Southport we know today.

DID YOU KNOW?
From the seventeenth century rabbits were farmed for food and sold locally. The adult rabbits were called coneys. Only the young animals were referred to as rabbits. The skins were also used for many other purposes.

The name Southport was adopted by newcomers to the banks of the River Nile as well by incomers wishing to live here, but it was not yet official. The whole of this coastal area was in the parish of North Meols, with Churchtown being the principal village. Further development in the area saw some new buildings erected alongside the main road through the new village during the early 1800s, along with plans for the creation of more streets off the existing one and only 'main street'. At each side of the street, running north to south, were sandhills with a street level lower than the beach. The street flooded at times following heavy storms and high seas, for, as yet, no work had started to the west side of Lords Street, where the sandhills remained to adjoin the beach. No sea wall had yet been built, nor were there any proposals to create a promenade road – yet.

The River Nile development area was becoming known as a 'bathing village' from which tales of frivolity and parties emanated. There had been too many comments 'that the visitors staying at their hotel or lodgings are of upper class, and as such should behave and set an example'. Apparently some nude bathing was occasionally seen in and around the beach and sandhills, which, I suppose, at that time would have been enough to make a lady faint at merely the thought of such things, let alone the sight!

A report in *The Modern British Traveller* (1805) is of some interest as it describes some of the things to be seen in South Port: 'The mildness of the air and the age of the

Painting of
Nile Cottage.

inhabitants ... Having a firm beach with Trawl Boats and a pleasure boat for trips to sea ... Neat houses have been built close to the hotel, with fine views to the sea.' A similar report can be found from 1808, which was written by a visitor from Yorkshire who came 'with his wife and daughter and manservant'. They travelled 'in a little cabriolet with our own horses and a little dicky box fastened behind' and said:

> We went to South Port, this place is a resort in the summer. Two miles in deep sand ... Many cottages built and let to strangers for Two Pounds or two guineas a week ... Several cottages now built by those retiring thither, but many of these have no views of the sea as the sandhills obstruct the view. There are two hotels, the older one being better, the company is not good in general. Two fishing boats go out at high water trawl until the next tide, they catch Flooks, Gurnett, Soles, some Turbot, black mouth, Cod and Ray. The men go out in boats which are old and past their best and at times are blown to the Isle of Mann or Ireland.

The writer also reports that a fight was advertised, which would likely be one fought with bare fists. Another former visitor to South Port was from Upholland, who said, 'It is becoming a famous place for bathing, undoubtably superior to Liverpool baths. There is no river water here but fine open sea with smooth sand that suits me well. I can ramble along the sands for miles unobserved and without the least dread of danger.' In 1809, the *Liverpool Courier* published a list of the 'fashionable' personalities due to visit the new bathing village.

More information relating to Southport just after the first decade of the nineteenth century comes from Richard Ayton, a walker, who was at the time en route from Formby Point and heading north towards the Ribble Estuary. His lengthy report, made in note form, has some interesting details relating to what he saw as he passed through the new South Port along the 'hard sands':

> Distant objects seem near but are deceptive and the miles are tedious and seem to be double their actual distance. One walks in wonder for an hour which I thought I would pass in half the time. I arrived at some bathing machines which I thought might retreat as I arrived. I paused at Southport. Amid a waste of sandhills, with a dozen or so houses in the style of natural and simple embellishment. The sand does not allow anything to grow, and gardens around have green palings. The gardens are adorned with items from wrecks, like figureheads of many types. The place was founded for bathers accommodation and all made pretty. I hopped over a small drain which I found was called the Nile. All has been provided for the indulgence of visitors who come hither with fine taste and romantic feeling. A person might travel far indeed without seeing anything like this Southport.

It is likely that our Mr Ayton could have met with William 'Duke' Sutton since he says, 'as the host of the Inn explained, if a contrivance could be made to transform the sand green, to keep it out of the parlours'. This was probably in reference to the blown sand entering the inn. Sutton had leased out his first hotel/inn, the South Port Hotel, and was now innkeeper at the Union Hotel.

Ayton has more to say about his journey through North Meols, especially regarding how he was to proceed out of the area; there were no horses for hire, so it was either to walk or travel on a cart. The new canal from Liverpool to Wigan was now open (it was mooted back in the 1770s) and passed a few miles south-east of Southport in the village of Scarisbrick.

It must have been a warm summer when Ayton wrote these notes, for he says:

The situation is disagreeable, on windy days smothering you with sand, or if calm, suffocating you with heat. When out of doors there is no tree or bush to fly to for shade, just sea, sand and sun. Visitors are trundled away in carts to the Wigan Canal, to go by packet boat to Wigan or Liverpool. On my arrival on foot at Churchtown, after walking through sand from Southport, I arrived at a paved road, making my journey less burthensome.

However, it seems that Mr Ayton liked this new Southport despite his conflicting comments. Some of the houses now being built in the new village were no longer of the cottage type, but were large family homes. Former cottages were also being enlarged. The new community grew rapidly as its popularity became better known to people further afield, who were now more able to get to the remote North Meols area to see what had been done as it was being quoted as 'a resort'.

The arrival of more visitors to the isolated Churchtown village inn during the 1780s or so may well have been due to the popularity of 'Bathing Sunday' having significantly dwindled. New visitors wanted to see and/or experience activities that may have died out. Sea bathing in North Meols had in fact been known about since the thirteenth century. This activity had stemmed from St Cuthbert's fair, held annually on 20 August. For some unknown reason (but possibly due to a large number of visitors attending the fair) it was agreed that on the Sunday after St Cuthbert's Day sea bathing should begin – later referred to as 'Bathing Sunday'. Although sea bathing may have become a thing of the past by the late eighteenth century, a revival was overdue.

As the new Southport village grew during the 1820s, so too did the houses. Many of them now had individual names such as Belmont Castle, with its crenellated walls, and Nile Cottage. Close by William Sutton's original hotel, to the north-east, was a row of terraced cottages called Wellington Parade (later Terrace). These predated other developments taking place close by and this terrace can still be seen today.

Architectural styles became more varied and grandiose close by the River Nile, which flowed approximately on the boundary between Birkdale and Churchtown, all within North Meols. But all of the land hereabouts was not suitable for building, especially around Churchtown. As we have seen, the further inland we go, the land gets wetter with marshland areas and this was particularly the case around Churchtown.

It has been estimated that the entire population of North Meols at the start of the nineteenth century was in the region of 2,500 people, which included the new village of Southport. The population of the new village is estimated to have been in the region of 300 or 400 at this time. By 1821 the population of North Meols was a little over 3,000, with perhaps around 500 of these in the village of Southport.

Improvements to roads had led to the stagecoach running into North Meols from other towns. More visitors now came by coach or canal, before heading on by coach to Churchtown and Southport. The new canal, later to become the Leeds to Liverpool Canal, was built from Liverpool to Gathurst only, where people heading from or to Wigan had to change boats to travel via the River Douglas Navigation to Wigan. The canal brought persons from all the towns and villages along this section of the canal or river as far as Scarisbrick, from where coaches carried visitors forward to their destination.

The period between 1815 and 1825 is reported to have been a decade of high seas, with many instances of high tides and damage caused to boats and moorings along the length of the coast of Meols, and as far south as Crosby. Tidal problems, however, did not defer the building of additional hotels along this stretch of coast. Consolidation through planting on the sand dunes was ongoing to reduce the drifting and wind problems during this time. Some areas of the dunes were treated with a mix of ash, peat, manure and a host of other items to convert the sand to arable use.

4. Lords Street, a Town Hall and a Sea Wall

Between 1800 and the mid-1820s several properties were built, along with individual houses and business premises, along the main street. In addition to this, side streets were also being marked out, some of which already had some houses while others were marked out into plots of land. There had been little work started elsewhere in the new Southport, other than for the proposed future infrastructure for drainage and other needs. The major activity to be seen was centred on consolidation work for building foundations. This required the removal of large amounts of sand after levelling for large dunes had been extant here prior to the creation of the new street. The new street was named Lords Street. The plural 's' was used because the parish boundaries, each with separate lords of their respective manors, met together along the line of this new street.

If we could imagine a walk in around 1830, it would likely be something similar to what follows. From the south end of Lords Street, starting by the Original (Duke's Folly) Hotel, Lords Street would be directly in front of us, stretching away into the distance. Walking north, on the left side of the street we find that five new streets are marked out ready to be laid out – two had already been partly built – with a few houses and one or two business premises. The new streets are to be called Coronation Walk, which has a few houses already built on one side; the next is Nevill Street, which crosses Lords Street and continues as London Street; moving further along is Bold Street, which crosses Lords Street to become Hill Street; arriving at Sea Bank Road, this crosses Lords Street to become Union Street; and, finally, arriving at Leicester Street, which crosses Lords

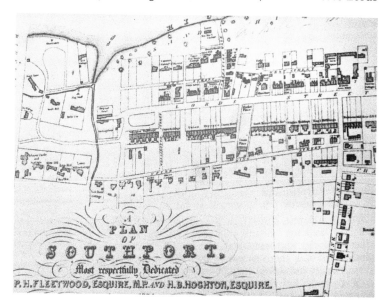

Lord Street building plan of 1834.

Street to become Manchester Road. At this crossroads Lords Street comes to an end; the road beyond, heading towards Preston, is called Peters Street and would later become Albert Road.

Of the five roads listed above, running towards the beach some quarter mile or so from Lords Street, the latter four of them extend to the beach's high water mark. There are not many built properties hereabouts but some are laid out to foundations and some are starting to be built. In addition to the latter four streets, there is to be another street crossing those running parallel to Lords Street, which has not yet been built.

Having completed our imaginary walk south to north along the new Lords Street, we will now return down the street, from north to south on the left side – the gardens side. We shall start at Manchester Road, still in around the year 1830.

As we walk towards Union Street there are two buildings called Brunswick Villa and Lark Hill, plus three cottages with long gardens running to Lords Street. Between Union Street and Hill Street are ten plots of land – all marked out – five of which are occupied by builders and three of which are at foundation only. There are two vacant plots. From Hill Street to London Street there are eight plots, which are all occupied. Between London Street and the next street, which is not crossing Lords Street, called East Bank Lane we have five large plots all built upon with the principle building being Christ Church. Next door to the church are four cottages (which would become the site of the Town Hall later) with long gardens running down to the street.

From East Bank Lane we have a long row of terraced property containing seven dwellings, all of which have gardens extending to the street. Next are three buildings referred to as 'Wrights Buildings', followed by another set of nine terraced cottages – all with long gardens. We come next to a market area adjoining an unmade, unnamed street, beyond which is the building that would become the Union Hotel. After this is Union Terrace, another twelve cottages that have long gardens to the street, then an unnamed street and finally another terrace of six cottages with long gardens. Next is a street that would be called Wellington Street, beyond which is the final terraced row – one of some age – called Wellington Buildings. It is comprised of ten properties with long gardens running to Lords Street, similar to the other cottages with long gardens extending to the main street. The roadway is not central between the buildings of the street, but it is nearer to the western buildings.

The last row of cottages was Wellington Parade, named as such to commemorate Wellington's victory at Waterloo. Having spoken with residents I was told they were originally built as fishermen's cottages. These were to be rebuilt later as they are only a short distance from the one-time River Nile and its estuary. We are now back close to the original hotel, having seen the progress so far achieved here in the newly emerging Southport.

In 1830 Lords Street was renamed Lord Street – one can only wonder why! Perhaps the lords concerned played a hand of cards with a winner to take all, or, in this case, lost their plural 's'. Perhaps one lord bought out the other parcel of land, or it might have been due to a toss of a coin that the 's' was dropped. At least neither lord would lose his name with this decision.

Progress with building along Lord Street during 1820–30 saw more interest from commercial businesses wanting to come to this new and fast-growing 'resort'. Hoteliers were approaching the 'village elders' with proposals and queries, plus intending new hoteliers were making enquiries. But the committee were unable to answer the proliferation of queries as they had their own plans to resolve concerning the removal of the sandhills surrounding the built area of Lord Street, as well as how to stop the high tide flooding of the main street and beyond into the new ones being built.

Building work also took in streets parallel to Lord Street. To the east was Chapel Street, which would join with Hoghton Street to the north. To the south, Chapel Street would join up to East Bank Lane, the latter lane already by c. 1830 had a row of houses along part of it. To the west side of Lord Street the parallel streets were also being marked out, and in some cases plots of land had been approved for development. One of these was West Street, a short street that joined with Bath Street at its southern end and lead back into Lord Street. West Street had no centre section in the early 1830s, but its northern extension ran north from Neville Street to form crossroads with Bold Street, Sea Bank Road and Leicester Street, before continuing on for a short way. This road had not been allocated a name at this point, but it would later become Stanley Street. The population at this time was around 5,000.

As the new main street for Southport was being developed so too were other sites, such as the beach and its meeting with the shore. The beach was at a level higher than Lord Street. At periods of high tide the seawater often came over the beach and into the sandhills, which extended to Lord Street. The flooding of Lord Street (and at times beyond) was a major problem, especially with the building work ongoing at this time. The removal of sand to create foundations, especially when it was wet, caused holdups and higher costs due to work taking longer to do. As such, a solution to the flooding became a priority. Setting an example to cure the flooding problem was referred to by the town commissioners, whereby a Mr Whitely built a stone embankment on the seaward side of his premises in 1821. The beachside Lodge shop was built later.

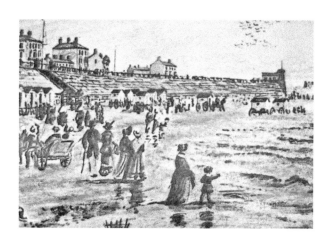

The Lodge and wall of
Mr Whiteley.

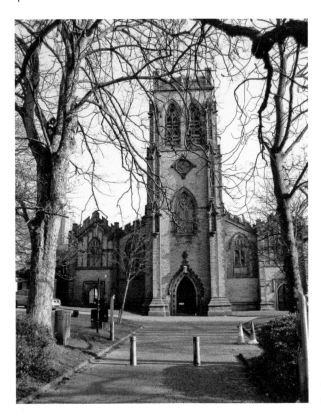

Christ Church Tower with the spire removed.

This wall inspired the village committee as to what was needed to create a promenade suitable for carriages and walking along, and to stop the floods. This wall was to be built above the high-tide mark running northwards, initially between Neville Street and Seabank Road, as well as extending to the south to join Mr Whiteley's private wall. Incidentally visitors to the Lodge shop, a forerunner of any beachside shop of today, had the opportunity to climb to the roof of the Lodge where a telescope was sited to view the area at a charge of one penny. The area behind Whiteley's sea wall was named Marine Parade.

The general development of Lord Street was well underway, as was the religious community. By 1833 four places of worship were available: Church of England, Roman Catholic, Wesleyan and an Independent chapel. The first church to be built in Lord Street was Christ Church in 1820/21. It was originally built with a tower and spire but sadly the spire and church walls were found to be in a poor state of repair during the 1950s so were removed. Today, with its internal alterations and café, the church is well worth a visit and is an essential part of the community. Incidentally, the tower still has a full peal of bells in place.

The second oldest church is Holy Trinity, with its striking red-brick and grey-stone arches. Courses of its tower are built in cathedral proportions. It, too, is another place to visit just off the north end of Lord Street in Manchester Road. The first church on the site was built in 1837 and demolished in 1903; the present church is built on the same site as the first and was consecrated in 1912.

By the 1850s Lord Street buildings were on both sides of the street, other than some plots already earmarked for buildings. Much attention was shown in the progress of the new building developments by commercial undertakings and banks, who were keen to set up or open extended branches of their companies.

Next to Christ Church, to the east side of Lord Street (on the opposite side to the shops), is Southport Town Hall, which was leased for 999 years in 1851 by the newly formed Improvement Commissioners. Cottages were demolished to make the site ready. A local architect named Thomas Withnell designed the building; the builder was another local man, one Thomas Stanley. According to records, the building was erected in ten months.

A Town Hall for Southport

The façade of the building is a mixture of three or four styles topped by a triangular pediment, within which are the figures of Justice, Truth and Mercy. The internal of the building was completed by 1854 and housed the Improvement Commissioners, police offices and station, with the cells in the basement.

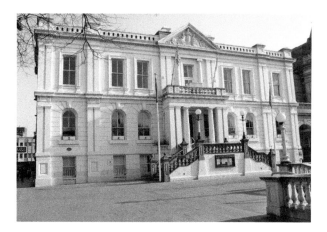

Southport Town Hall, west front.

Southport Town Hall, upper pediment.

The offices of the Scarisbrick Estates were also here. Apart from slight internal alterations the building remains as originally built, and is worth a visit to see the Council Chamber's wonderful wooden panelling and stained-glass windows. The building can be hired for weddings today. Visitors may visit the building by obtaining permission from the entrance reception.

More cottages stood next to the Town Hall. These were also demolished, and were replaced by the Atkinson Art Gallery and Atkinson Library during the 1870s. Money for this project was donated by Mr William Atkinson at a cost of £13, 500. The foundation stone was laid in 1872 by Princess Mary of Cambridge, Duchess of Teck (Germany).

Next door to the Cambridge Hall was a row of cottages called Richmond Hill. These were demolished to build the West Lancashire Bank. This building became the Atkinson Library and Art Gallery with a Science and Art School behind it.

Southport Town Hall, Council Chamber.

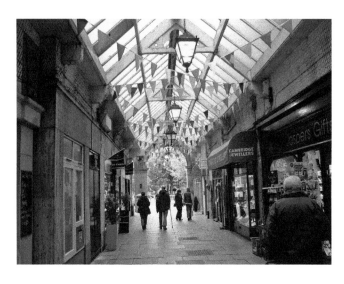

Cambridge Building.

The Town

The new promenade was immediately popular, with visitors as well as developers keen to establish new places to live along this enviable location overlooking sand and sea. It was not long before additional properties were being built to the north. The few that were already there were mainly private houses, along with the Victoria Baths building at the north corner of Neville Street and the promenade. At the south corner of Neville Street was the Victoria Hotel, which opened in the 1840s behind the sea wall that Mr Whiteley had built and extended later.

The Queens Hotel of the 1860s was the first to be built on the new promenade at the corner of the appropriately named Victoria Street, close to the baths that were rebuilt in 1876. The baths catered for first- and second-class clientele, and, of course, had separate entrances for ladies and gentlemen. The baths had originally opened in 1839 and had a refreshments room, a gallery, showers, a conservatory with many plants, and tepid

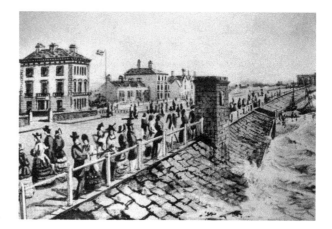

Victoria Hotel on the Promenade.

The town's coat of arms on a lamp post base.

and cold swimming, salt or fresh water, as well as having at your disposal 'with every convenience, and the most civil and obliging treatments'.

In Lord Street shops were largely built to the west side and catered for all, but were often quoted by visitors as being 'a bit upmarket', though all classes of visitor were happy to browse/visit the canopied shopfronts and tearooms, as they do today. There were a large number of shops built that were directed towards the ladies of the Victorian era, selling dresses and all manner of clothes and hats.

The *Southport Visitor* newspaper (first published in May 1844) had a section devoted to fashion; one might say it was equivalent to today's glossy magazines. Some of the items are well worth looking into for their suggestions relating to clothes and courtship matters! Although, if fashionable ladies and gentlemen were to be seen parading the street and cafés of the time, those streets had to be tidy and easy to walk upon. As it was, during the building of the streets, shops and other properties the footpaths and roads were often unmade, unpaved and more of a liability to walk upon during the hours of daylight. At night the street was even more of a hazard, with little or no lighting save for candles or oil lamps – though a limited supply of naphtha gas was made at the Crowland depot in 1846 and fed into the mains for some of the streets being built. But this was inadequate for a town like Southport that was growing in size and population.

Lighting was only one of the concerns of the village committee during the 1840s and 1850s, who were preparing for the town's Charter of Incorporation to make it a borough. (Up to this time the new village had come largely under the jurisdiction of the parish council at Churchtown, along with the lord of the manor.) Other issues demanding attention were the sewage/drainage disposal, water supply, a need for a gas-producing plant and a need to make all the footpaths safe to walk on during the development works, as well as to improve roads in the town.

The Act of Incorporation was granted to Southport in Parliament in 1846, giving the decision-making responsibility to those persons elected onto the new board with the right to deal with their own local affairs. Twenty-three people were appointed onto the first Southport Improvement Commission, including the lord of the manor.

A Visitor from France

It was during May 1846, that a celebrated 'royal personage' came to visit the town, staying at a residence in Lord Street that was still incomplete but far enough along with the construction that the visitor was able to walk among it and see for himself what was in the process of being created here. That 'personage' was no less than Prince Louis-Napoléon Bonaparte of France.

Few details of his time spent here are available, other than his entertainment and visits to places, plus the inevitable invitations to the houses of the local gentry. Although I have not found details of his length of stay here, we know that he likely took away with him a very special memory. He quite possibly left a memory in Southport too, especially concerning a name applied to Lord Street.

Louis-Napoléon Bonaparte became Emperor of France in 1851. After about a year in office, he instructed his officials that he wanted to transform the old city centre of Paris – unchanged from medieval times – with its narrow, unhygienic alleys and streets, into wide tree-lined streets. This work was put in the hands of Baron Haussman, a task that was ongoing for some years. The outcome being the wide tree-lined streets we see in

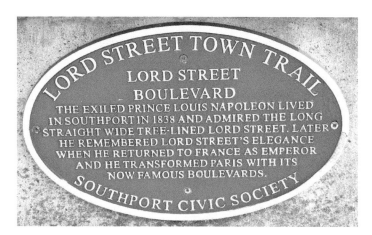

Historical information plaque.

the Paris of today. Perhaps the idea for this transformation of the old Parisian streets had come from his visit to Southport. I wonder if it was his suggestion, on seeing the developing Lord Street, that he may have said to the local officials or gentry that this new street looked like a French boulevard – a name often used in reference to Lord Street today. Perhaps this is yet another 'secret' that we have here in Southport.

The post-inauguration of the Improvement Commission saw a proliferation of projects in the pipeline for Southport, with several having to be shuffled about as far as priority was concerned. Projects included the development of areas beyond the main shopping centre of Lord Street, along with the associated infrastructure that would be necessary; plus improvement and increase of the number of street lights of these developing streets outside the centre of the town.

The Railway Arrives

Other considerations and agreements were the building and near completion of the railway from Liverpool (which was in fact completed in 1848) and the requests from other towns such as Manchester and Preston for railways to be built from those towns to the burgeoning Southport. Up until this time the increasing number of visitors to the town arrived either by their own horse-drawn coach or via the Liverpool to Wigan branch of the canal as far as Scarisbrick.

In the meantime, the increase in visitors had shown that more new hotels were necessary. In fact some of these were being built at this time. Additionally, the visitors needed some facilities for their amusement and occupation. To which it was stated officially 'was non essential compared with the need for a better water supply, and street lighting'.

DID YOU KNOW?
The so-called Viking invasion of the north-west coast in the ninth century was one of gradual settlement. They came from Ireland as traders, not invaders. Many places in the Merseyside area have place names of Viking/Norse origins.

The fleur de lys on the
Prince of Wales Hotel.

The 'to do' list did not end there for the new Commission. A market was wanted by the settled townspeople, who pointed out that it would be a facility for visitors also. A market was one of the Commission's early projects and was provided in 1846. This was followed closely with the successful deep boring for a freshwater supply in that same year.

In 1851, following the acquisition of Spring Field Cottages adjoining Christ Church by the Improvement Commission, plans for a Town Hall were drawn up. A lease was obtained from Mr Charles Scarisbrick. The architect was Mr Thomas Withnell, who was also the architect for the market hall, part of the Promenade Hospital and the Royal Hotel.

In 1853, the arrival in the town of its second railway (this time from Manchester) was greeted with much anticipation of the probable increasing numbers of visitors to arrive. However, this was cancelled out it seems by local gossips when it was pointed out that Southport residents could now make the journey there and back to Manchester in one day. This seemed to even out the 'for' and 'against' arguments. By 1856, the developing village had a population of 8,000 persons.

Despite considerations by the town committee there was a marked absence of things to do for the visitors, who were working folk more often than not, here for a day. Due to the development of the railways there were an increasing number of visitors who wished to stay in Southport for longer, but the hotels were quite limited at that time and expensive for many. Amusements and entertainments were very limited too. Over the next few years that would be much improved by the council. Not all residents favoured these changes but some became benefactors in many different areas for the general good of the community.

The later 1850s saw some memorable events and celebrations in the growing town, such as a new hospital for the poor and sick. Whitworth's 'Great Gun' was set up and test fired from the Birkdale sands to a target at Formby Point. A new market started being built in Chapel Street during the 1850s, opening in time for Christmas 1857.

Celebrations took place in the town with the news of the end of the Crimean War in 1857. During February 1858 a captured Russian gun from the war was presented to the town's Improvement Commission by Lord Panmure, Secretary of State for War, as a thank you to the people of Southport who had done so much to support the fundraising activities during the conflict.

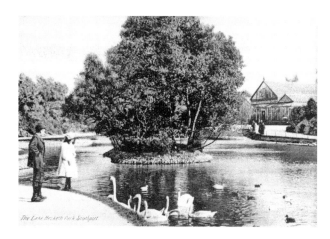

Hesketh Park.

The Commission pointed out that it could not be put on display unless it had a suitable carriage onto which the gun could be secured. A gun carriage was purchased for £16. The gun (an eighteen pounder) was mounted on the carriage and put on display in front of the Town Hall. It was fired from time to time and eventually moved to Hesketh Park, where it remained until 1940 when it was removed as part of the scrap-metal drive, along with metals from many other sources such as railings and signs.

Returning to the concerns of the town commissioners and their enigma of creating entertainment and things for the visitors to do again: one of the proposals was to create open spaces that could be accessed freely. This additional discussion point seems to have been given to a Parks and Cemeteries Committee, who also discussed the beach and sands, along with ideas to expand these facilities through activities such as boating, fairgrounds and even bowling.

Heavy storms over the winter months of 1857–59 caused much damage to property and resulted in many ships being grounded on the sandbanks offshore. A large number of deaths by drowning occurred as well as total losses, in many cases, of the whole ship.

Ships bringing cotton from America had reduced due to the pre-war status within the ports of America prior to the start of the Civil War; it was especially sad for their cargoes to be lost when so close to the port of Liverpool after crossing the Atlantic Ocean. With the onset of the war, vessels from the northern states created a shipping blockade to stop foreign ships entering the southern state ports to collect or land their cargoes, so the export of raw cotton in bale were much reduced.

The local handloom weavers of the area, particularly in Churchtown, became short of work and eventually had to stop weaving altogether for a time.

As if the local commissioners did not have enough to be concerned with at this time, there was one local 'situation' that always seemed to be 'resolved temporarily' (like some situations today!). Improvements were requested by residents regarding the need for a 'decent market' for the growing town. The local fishermen quickly sold their catch fresh from the sea when the boats returned as there were several fish shops already in the town. Here was another domestic problem for the Commission: was there a need for a separate market place for fish sales?

Footpath Tile by Buckley.

A Pier for Southport

Following much publicity a public meeting was held in March 1859 that was addressed by the Chairman of the Improvement Commission, Dr Peter Wood JP. The purpose of this meeting was to obtain views and opinions of the general public to a proposal already studied by the commissioners. The meeting agenda was to agree to the formation of a company to spearhead the building of a pier. This would extend from the promenade outwards to the approximate low-tide position of the sea. The capital expenditure was expected to be around £8,000.

The meeting was well attended and many views were raised, as well as some uncertain comments. But positive responses came from the hoteliers and shopkeepers who could see a future increase in sales with the additional visitors likely to come to Southport. It was agreed by the meeting that a company would be formed to move the discussions forward into on-site action.

Details of the pier construction were tabled along with drawings for the public's information. The length of the pier was to be 1,200 yards. The promenade end would be 13 feet to the lower deck supporting girders, plus a further 3 feet to the actual footway decking. Above the sand at the seaward end it would be 22 feet from there to the lower deck girders, plus 3 feet above to the actual deck.

The contractor, selected from quotes obtained, would be Messrs W. and J. Galloway from Manchester, and the engineer was a Mr James Brunlees. The Pier Company lost no time in getting the contractor on site quickly during the summer months of 1859, and excavation work at the promenade was underway by June, with steel columns and beams being delivered to the site by August.

A problem with boring out the holes for the piles to support the tubular columns was created due to the sandy nature of the site, which was prevalent throughout the process; not to mention the tidal problems that occurred due to heavy seas. On 14 August 1859, the first of the support column piles was driven down into the ground – watched and cheered on by a large group of onlookers.

5. Foreshore Changes and Things to Do

One of the earliest decisions of 1860 made by the Improvement Commissioners was to commemorate the founding of the town by William 'Duke' Sutton, close to the River Nile, at the south end of what would become Lord Street. A street lamp was erected in the middle of the road, though was due to the increase of traffic.

A short way down Duke Street a modern hotel called the South Port Hotel can be found. As well as being the original hotel, in name as well as presence, it became the South Port Hotel but was widely referred to as Duke's Folly. The 'original inn' had other names later as well, prior to its demolition. A short walk on and we arrive at another building, with classical features. This was a United Free Methodist Church built in the late 1890s. Its column tops and frontage with portico and pediment can be paralleled with other Lord Street building features due to the same architects being responsible for their design. These were Messrs Maxwell and Tuke from Bury. The Masonic symbol in the pediment indicates the building's use as the Southport Masonic Hall.

If you have the time, heading half a mile further along Duke Street, across the railway level crossing, will bring you to the cemetery. It is a place with two entry lodges each side of the gated entrance, and a row of buildings facing you a short way past the gates, complete with a central clock tower. The buildings are rather tired-looking now, and are used for storage and graveyard maintenance work. The cemetery has some poignant and evocative gravestones to read, including the tomb of the Southport lifeboat men who lost

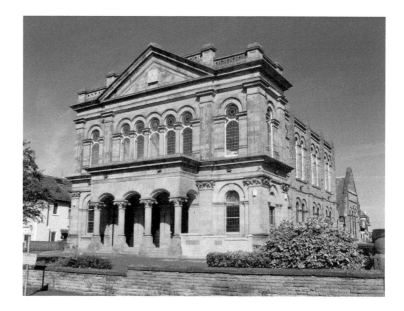

The former United Free Methodist Church in Duke Street.

their lives in the 1880s *Mexico* vessel disaster. The commemorative tomb is to the rear of the central clock tower archway, and directly in line with the footpath.

DID YOU KNOW?
Southport's first tram service began in 1873. This was drawn by horses until the system was electrified in 1900, after which more routes were opened. Many of the early tramcars were built in Preston.

Returning to the Lord Street roundabout we continue towards the Esplanade and the Foreshore. As we have mentioned previously, the sea used to come in to the sandy beach as far as this – where today's footpath runs alongside Kings Gardens. But now the tide was retracting and no longer coming up the beach to the promenade along the whole length of the Southport shoreline. This was particularly so to the south end of the beach and the boundary with Birkdale. The former beach line continued to the south, roughly along the line of today's Rotten Row, curving inwards into Birkdale. Where Victoria Park is today was at one time all beach.

Two unusual records exist pertaining to May and June of 1860. The first unusual – yet informative – event concerned a marriage held in the open air at St Cuthbert's in Churchtown. The reason for it being outside was because the church had been three-quarters demolished prior to its rebuilding and enlargement; only the tower with its spire and a part of the wall by the entrance door remained. The body of the church and alter areas were cleared of rubble to allow the ceremony to take place.

The second unusual item concerned the death and death request of Squire Charles Scarisbrick. This request gave instructions that 'his body should be taken to the funeral chapel for internment, in a direct line from his place of death'. This apparently caused some consternation among his family and the undertaker because it meant that a route had to be created, passing through 'a potato field, a wheat field, several hedges, cover some ditches, across a meadow then through a private garden into the chapel yard at Bescar Lane RC Chapel.' It would be interesting to have heard some of the local people's comments living nearby as to what they thought about the funeral route.

During July 1860 Christ Church was enlarged to allow 500 more people to be accommodated. Also, once again we come across a reference to that 'Big Gun' of Whitworth's being brought to the beach at Birkdale to be 'tried out'. But it was in the following month that the big event took place. This was preceded by a gala and large procession, plus official banquets and balls, as well as crowds of people along the promenade. Additionally, a fireworks display took place as well as some illuminations.

The event was the official opening of the pier. The date was 2 August 1860. The opening was performed by Dr Barron, chairman of the Pier Company, who referred to

'Mr Boothroyd being the prime mover in the bid for a pier, who had pursued his objective despite problems along the way.'

Opposite Seabank Road, a small stream entered the sea. Here, boat trips could be obtained by visitors. This site would close now the pier was open. This location was used by workers involved in the shrimping business, one of Southport's specialities, which saw the name of the town known far and wide for taste and quality of its 'potted shrimps' or cockles.

At the seaward end of the pier were steps down to the sea. They were not accessible to the public and were used by local fishermen to get to the usually large number of fishing boats moored/anchored close to the end of the pier.

DID YOU KNOW?

The first Southport Flower Show was held in 1924. It was advertised as 'A Grand Floral Fete with Horse Jumping', and was held at Victoria Park.

If we could have stood at the junction of Coronation Walk with the promenade back in 1860 and looked to the right (north), we would see a promenade roadway with a sea wall adjoining the sands.

If we were to look to the left (south) we would see a curving line of beach, running slightly inland further to our left, where Rotten Row would be built later – this was the Birkdale Beach and estuary of the River Nile. In front of us, the sandy beach and sea came up to where today we have a footpath alongside Kings Gardens. The beach and sea would be the only things visible, unlike our present-day view of the Esplanade, Pleasureland amusement park, Victoria Park, Prince's Park and boating lake. All of the area is there today because of the sea's withdrawal.

The success of the pier venture was good news for the commissioners, who were still looking into how visitors and residents could find entertainment. One fact that had emerged since the opening of the pier was that a new system of moving vehicles running on rails using a fixed engine was being tried out – the tram. The Commission decided to have this system fitted on the pier. This work was completed in 1864. The system operated using an engine to turn a long cable that could be gripped and released as a method to stop or go forward or back. The tram ride out and promenade walk back along the pier, or vice-versa, was well favoured by all.

Steamers had called at Southport prior to the extension of the pier. The steamers sailed to many ports: from Barrow-in-Furness, Blackpool and Preston to the north, as far as Llandudno in north Wales to the south. These sailings were especially popular in the summer.

The frequency of shipwrecks off the shores of Ainsdale, Birkdale, Southport and the Ribble Estuary saw not only a great loss of valuable cargoes and vessels, but their

crews as well. Since 1816 a Marine Fund had been set up in the town, which led to a local branch of the RNLI in 1824 and a lifeboat (that proved to be totally inadequate) was built. In the 1840s another purpose-built boat was made. This served as the official lifeboat for Southport, aptly named *Rescue*. The rescue successes in the past had been done by volunteer fishermen used to the vagaries of the seas.

The first lifeboat presented to this coastal area was named the *Jessie Knowles* and was allocated to Southport by the local RNLI, who were aware of the number of deaths by drowning of crews and passengers, as well as some of the volunteer fishermen attempting rescues. The christening of the boat was carried out by Miss Lizzie Knowles, daughter of Mr James Knowles from Eagley Bank, Bolton, who was the benefactor of the boat. 'Jessie', it seems, was the younger sister of Lizzie Knowles, who performed the launching close to the pier.

The new pier was a great new attraction for the visitor. Coming up with new attractions was one of the major concerns of the Improvement Commission, who were keen to continue with projects of this kind. Already in hand were plans to create the open spaces for visitor picnics, along with play areas for children. Other major works were the subject of many meetings of the town Commission. It was into the 1870s, though, before any other major works took shape along the Promenade or what would become the foreshore.

The commissioners appeared to be preoccupied with the foreshore and the improvement of this area for residents, and the ever-increasing number of visitors now coming to Southport. Within the town there were other works to be done in the streets themselves, which, from the 1860s, had been shelved regularly. However, after the Tramways Act a company was formed to set up a horse-drawn tramway system in the town between Churchtown and Birkdale via Lord Street. The first horse-drawn tram route was opened in May 1873.

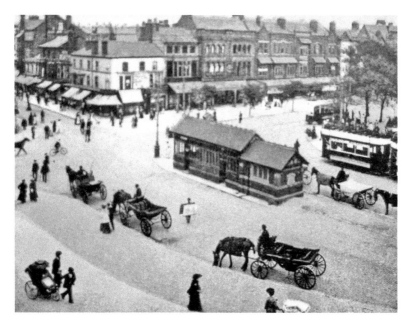

Horses and trams in London Square.

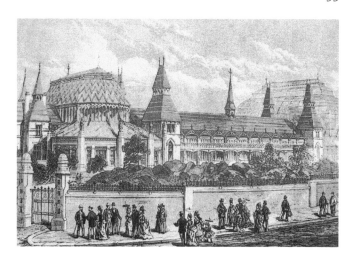

The Winter
Gardens complex.

In 1872, the foundation stone of a large new building was laid in Lord Street. This was to become Cambridge Hall. Another government act was the Public Libraries Act, which was adopted by the town Commission and a temporary library was quickly set up in the Exchange Building on London Street.

As part of the ongoing discussion relating to entertaining visitors and residents alike, the town Commission met with a group of investors who proposed that a winter garden building could be the answer to their problem of things for visitors to do. Once again public announcements and meetings followed. The public applauded the proposal for such a grand building, which was to be built adjoining the beach on the spot where Morrisons is today. In the 1870s the beach ran across where the supermarket car park now is.

The new Winter Garden Building was to be some 180 feet long (north–south), having an H-shaped plan. Its maximum height was to be 80 feet. Its construction would largely be a metal frame with glass panels as appropriate to the function of the building's interior. It would comprise one central 'corridor or promenade' linking two end buildings that would run east to west. One end building would be a concert hall called the Pavilion, which was designed to accommodate 2,500 people.

The other end building would be a large 'winter garden', or conservatory. This was promoted as being 'the largest conservatory in England', as well as being the first winter garden at any seaside resort and it was certainly the biggest building to be erected on a seafront in the country. (As a matter of interest, the Kew Gardens Conservatory, or Palm House, is a little over 137 feet long by 63 feet high – Southport's was the bigger building!)

To the rear of the building was an open promenade area that adjoined the beach. The main entry into the complex was via Lord Street. The company formed to run the building was the Southport Pavilion and Winter Gardens Company, who were based in Southport. The building was opened on 16 September 1874, with the general public having a choice of things to see and do including an opera house, conservatory, theatre, aquarium, a small zoo and refreshment facilities, as well as halls and promenade areas. But it was regarded by many as being a little 'up market for their taste'. But no statistics seem to have been recorded appertaining to these comments!

Despite the successes there were concerns that were the subject of many discussions within the Improvement Commission ranks. One of these concerns related to the studies recently undertaken to record how much the sea was withdrawing from the south beach, which had now become a major concern of the as-yet separate Birkdale authorities. The tide no longer reached high up the beach to its former line, even at high tide. No answers could be resolved and 'studies to continue' was the byword for the time being.

Improvement Schemes

At least the Commission had some good news around this time, for their policy of having more open spaces and parks was showing some good works. In May 1875, the Botanic Gardens in Churchtown were opened by Revd Charles Hesketh. A large conservatory was also to be built within the park. To commemorate this opening event, Rev Hesketh laid a foundation stone in the conservatory.

The Improvement Commission's meeting (also held in May) was to agree to a new Improvement Bill for the town. It would incorporate the following works: extend the Gas Works, £220,000; new markets, £40,000; £7,000 for workers' houses; £5,000 to create a new town yard and £3,000 for a series of general works to be carried out.

The promenade sea wall was extended northward towards Leicester Street; by now the sea was still occasionally running up the beach as far as this central promenade. But at the north Promenade end the shoreline turned inwards, to the north-east and curved towards Crossens Village. The former beach area here was greened over with marshland grasses, with partial (and occasional) tidal coverage. Here, too, the retreat of the sea covering was evident. This area would become the site of the Southport Golf Club later.

Reclaiming the Land

Along the central promenade beach between the Winter Garden building and the latest extension of the sea wall and promenade roadway, the normal tidal covering of the sands continued, but not with every tide. This was due to the fact that this section of the shore was a little further out to the west, and as yet the tidal retreat was not so evident as it was to the northern and southern ends of the promenade; those beaches were first to be noticeable for the sea's withdrawal.

The Cheshire Lines Railway (originally running as far as Aintree) was later extended to Birkdale, intending to continue into Southport itself. This move was shelved for some time as a finite track route could not be established into Southport. With the retraction of the sea from the Birkdale beach, it was agreed by the railway company and the local authorities that a route into Southport could be via a raised embankment curving outward from Birkdale, crossing the former beach and then curving back into Southport. The embankment for arrivals to Southport was built approximately where the Eco Visitor Centre is today, running towards the proposed station site.

The enclosed area of land where the beach had been, within the curving railway embankment, was filled in and levelled to become a leisure/play area. Today Victoria Park takes up much of this reclaimed area. By creating this new area of land, the former sea wall previously running along Rotten Row was removed and a combination of embankment and sea wall was created on the seaward side of a new embankment, on top of which trains would run to and from Birkdale station to the new station in Lord Street.

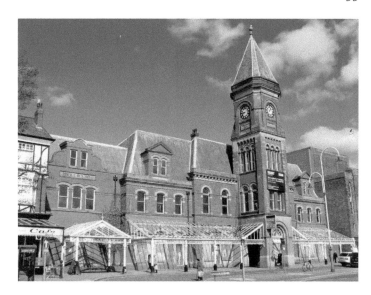

C.L.E. Railway station frontage.

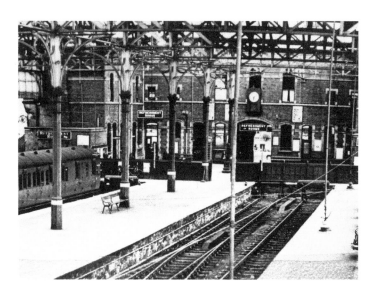

C.L.E. Railway station platforms.

The station terminus for the Cheshire Lines Extension Railway was to be built close by the Winter Gardens Conservatory at the south end. It would be called Southport Lord Street as its entrance was on that street. The station was opened on 1 September 1884 with five platforms.

The year 1885 was another significant one for the town as its first MP was elected for Southport Division. This same year saw the purchase by the local Commission of the Central Foreshore from the estates belonging to the Hesketh and Scarisbrick families.

A further embankment was created along the Southport beach between 1884 and 1886. This time it started from the present-day Eco Centre location, running north to the pier, then turning inland parallel to the pier on the north side, ending at the existing Promenade. Once the embankment had been consolidated, filling in began to create a

second area of reclaimed land. A square depression was left in the centre of the enclosed area, which was to become a boating lake. Work was completed and the lake opened in the late 1880s.

To the west side of the new lake (to become known as South Lake later) the reclaimed land, yet to be fully consolidated and settled, was open grassy space for a time. This later became Prince's Park. The edge of the new lake would be made up as a linear rock garden with a footpath running alongside the lake. Alongside the path a narrow gauge railway, established by Messrs Llewelyn, would be built from 1911, running the length of the lake.

On the promenade side of the lake, gardens would be created adjoining the Promenade, and additional walkways and pavilions between them were built later. At the south-east corner and southern side of the lake, a gradual influx of amusements then roundabouts gradually appeared. These were followed by stalls and Pierrot shows, as well as the general mix of fairground attractions. It became well-visited and popular fairground. The promenade side of the boating lake was left shallow to allow paddling in the water.

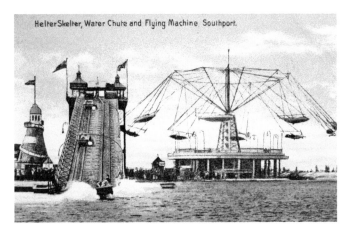

Lakeside Fair.

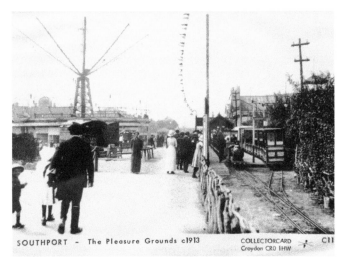

Lakeside Fair.

The boating lake was very popular with visitors and locals alike, as was the pier. Despite this, even more schemes were to be introduced, especially ones that would further enhance the promenade and foreshore area. Different ideas were given much discussion and based on the attendance and takings for the attractions currently available such as the pier, boating lake, amusements and fairground rides. The Commission agreed to a proposal to extend the lake as long as it should be separate to the existing lake, south of the pier. The new road proposal was also agreed to and would be built after the new (North Lake) was created. It was agreed that work would start on the new schemes immediately.

The new lake would be created to the north side of the pier with its east side adjoining the Promenade. A new road would be made close to the North side of the pier, which would give access to the beach that would be retained west of the new North Lake. It was also proposed that a sea bathing lake could be built in this beach area, as well as a future a family funfair.

The new road would bridge the North Lake, which would entail similar work being carried out as undertaken for South Lake, by constructing an embankment to retain the lake water. The new road was to be named Marine Drive. The length of this new Marine Drive would be less than half the length of the road we have today alongside the pier.

The west side embankment of the originally excavated North Lake can still be observed from the new Marine Drive Bridge. At the new bridge, take the right-hand footpath from the promenade and look over the bridge parapet to see the line of the original west side embankment excavations below to your left. This is aligned with the side of the islands to the north and was the size of the original lake.

Work on the embankment for North Lake and its surrounding edges was completed along with a bridge and Marine Drive around the same time in 1895. During the excavation work and subsequent filling of the new North Lake, it was decided by the Commission that if the lakes were joined below the pier after the new Marine Road was built, it would allow a greater area for pleasure boat trips and rowing boat hire. It would

South Lake and
Marine Way Bridge.

also reduce maintenance costs having access to one lake instead of two separate lakes. In late 1895 the lakes were joined.

The fairground area extant to the south-east and the southern end of the boating lake had become very popular. Its attractions already having been added to, it was time for a new attraction of spectacular size and excitement. An aerial cableway was erected in 1895 to carry passengers in a 'boat' suspended from cables across the width of the lake, secured to towers at each side. Despite this ride's popularity the height of the tower structures were cause for complaint from visitors and hoteliers alike as they 'spoiled the view over the lake to the sea'. But no complaints had been raised about the other large rides; for example the huge water chute, the helter-skelter and the famous Maxim's Flying Machines (like the one at Blackpool Pleasure Beach today). Despite the complaints, the aerial ride was not removed until 1911. This fairground would be relocated to another site close to the south-west corner of the lake later. It was named 'Pleasureland', and is still a major attraction today.

The pier was to see Thom's Tea Room built at its seaward end, of which its roof would become the place used by the famous 'professors' of the time. These professors were in fact high divers, who dived from the top of the tearoom's roof into the sea some 40 feet below at times of high tide. Their audiences were large and all paid a small charge to watch their dives, often from bicycles or raised height platforms. The title of 'professor' was used by the divers as a prefix to their names. It was certainly not a result of their education, especially if we consider what they were doing to earn a little money. Band concerts were part of the pier entertainment and were performed with either a military or visiting local brass band.

At the start of 1900, after a period of installing electricity in the town, the trams became electrically driven. Plenty of research had gone into this: a year-long fact-finding tour, in fact, of other towns experimenting with the newly introduced electrical systems. Visits were made to Liverpool, Blackpool and Bolton, where tram systems were introduced between 1898 and 1900. Work on the Southport system began in 1900, laying new rails and electric cables underground where the horse trams had run. New routes were served with overhead wiring.

On opening day on 18 July not all of the route system had been completed, but despite this four open-topped cars – filled with the Mayor, councillors, tram company officials, plus many other guests – rode around the streets on the flower-decked trams, watched by large crowds of people. The first batch of the electric trams were built by Messrs Dick Kerr in Preston.

There were three routes on the electric tram system, all starting from Hoghton Street in the town, and running to High Park Place, Hart Street and Ash Street. These routes were extended gradually until some 17 miles of tram routes were available within the Southport area.

Despite the above tramcar data, there is one rather special scheme relating to the tram system in Southport, originating in 1896. It could be of relevance today or perhaps even in the future. Today it is a historical document only; it never became factual. But what a secret! The project concerned another route for the trams across the River Ribble to Lytham, Blackpool or even to Fleetwood or St Annes. The river was to be crossed by a transporter

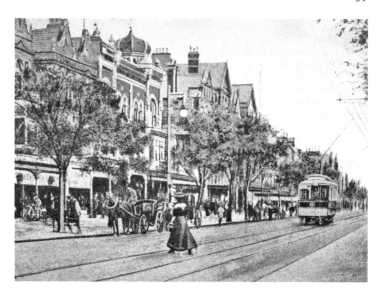

Trams on Lord Street.

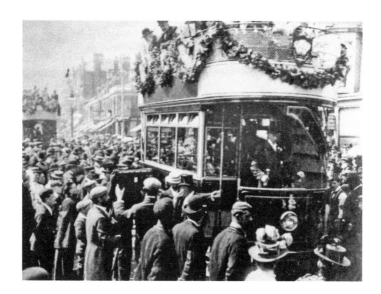

The opening of the
electric trams.

bridge that would carry the tram on a set of rails within a special support platform, high
above the river with its passengers. All of which would be suspended below the bridge
spanning the river. This bold venture was being bantered about between the 1890s and into
1906. With many schemes suggested, the Southport and Lytham Tramway Co. was formed.
Even a route from Southport to Preston was put forward. The scheme never got any further
than discussions, costings and drawings – but what a venture to consider.

Easter of 1900 saw a large increase in the number of visitors coming by train in
comparison to previous years, yet the Cheshire Lines Railway running into Lord Street
station does not seem to have prospered well, for it was sold to the Lancashire & Yorkshire
Railway later in the year. Public attendances at events at the Winter Gardens Pavilion fell,

leading to a greater range of the popular variety shows being presented; the name was also changed from Pavilion to Albert Hall.

In the first twenty five or so years of the twentieth century there were a number of other projects: the building of a new Pavilion between the pier entrance and Marine Parade; the addition of more buildings at the seaward end of the pier; a day nursery for visitors' children was set up alongside Marine Parade; Queen Victoria's statue was moved from Cambridge Hall Gardens to Nevill Street in 1912; a children's paddling pool was built on the beach alongside North Lake and a larger children's amusement area was set up on the beach here – these amusements were to become Peter Pans Playground.

The following year, in July 1913, George V and Queen Mary visited the town on their tour of Lancashire. Subsequently, the gardens between the promenade and west side of the boating lake were named Kings Gardens to commemorate the King's visit. With the relocation of the fairground from South Lake to the Promenade, the Kings Gardens were extended to the south end of the lake and bowling greens, with a pavilion were created here.

The filling and consolidation of the enclosed North Lake surrounding the embankment continued into the 1920s. The lake extension was of great satisfaction to the sailing organisations using the lake; its enlargement would lead to more competitive sailing events and the building of new facilities for the boats, along with improved leisure facilities for club members to the west side of the enlarged lake.

Following the relocation of the lakeside fairground to the new Pleasureland site, it was officially opened in 1922. Another royal visit took place in 1921 with the arrival of the Prince of Wales. The land to the north of the new Pleasureland was designated as a park was to become Prince's Park. The circular open-air Sea Bathing Lake would be built later (in 1928) on this reclaimed land.

The year 1923 saw the end of an era with the ending of the steamer services from the pier jetty to Wales, various Lancashire ports, and north to Barrow or even the Isle of Man. It was a service that was very popular with residents and visitors alike. The problem leading to closure of the service was due to the silting up of the channel, which allowed the steamers to come alongside the pier jetty.

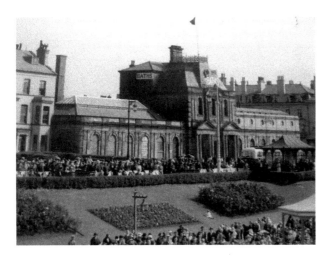

Victoria Baths, near fairground.

The following year was another memorable one as the first Southport Flower Show was held. The beach at this time became a venue for motor sporting events and speed record breaking, which is a story in itself and is too long to relate here.

The Floral Hall was another iconic and much favoured place to visit, built in 1930/32 at the end of the Marine Parade between the north lakeside and promenade. With its dancing facility inside amid its art deco styling, it was a much favoured place; as were its gardens, particularly to the south end of the building. Here was a small stage where performers or bands 'did their thing' while holidaymakers sat or dozed in their deckchairs, rapidly eating ice cream before it melted in this suntrap. This was a gem to have lost, and so popular a place to relax and 'people watch'.

I often wondered who gave the order to build over that important open space, which gave so much pleasure to so many people. Perhaps it was the same who allowed the circular Sea Bathing Lake on Prince's Park to be rundown and subsequently demolished, instead of covering it with a dome so it could have been used for so many events. (I, too, was one of the petition supporters for retaining the circular building!)

A three-arch bridge was built across the South Lake from the promenade to access Prince's Park during 1932. In the park another building called the Colonnade was built, close to the bridge access pathway. This semi-open-air theatre was another popular venue to sit outside in deckchairs and be entertained.

Floral Hall.

South Lake, one arch of a three-arch bridge over the lake.

The 1940s, during the wartime and the post-war era, were less of a time of moving forward with plans and new projects for the promenade and foreshore development. Similar to within the town itself, the work carried out here was essential only – more maintenance than new work. There was a shortage of investors for project work. This lack of money cascaded down to give a rundown appearance to many of the main properties and outdoor venues, including parks and gardens. Stripped of the railings, many sites were uninviting. Hoteliers had visitor numbers well down on pre-war years. Some smaller hotels closed permanently, or for a time until things improved.

The austerity years lasted until the early 1950s due to a reduction of train services – a result of rolling stock and lineside spare part shortages and track repairs. However, around this time the motorcar had become the transport mode of choice for visitors, whose numbers began to rise once more from around 1952. This first became apparent by the rise in attendances at concert or cinema venues – despite the introduction of television, it was still only in a few homes.

The 1950s was a time of recovery, as well as being a time for holidays abroad for some. Business orders were up as well as investments, especially so in the building trade, all of which led to more employment being available. As a result of the greater employment opportunities, people had more money to spend on a holiday or a day trip to the seaside. Just as things were improving in Southport there was a serious fire at the seaward end of the pier in June 1959, which destroyed the refurbishment on a newly completed café, a bar and amusement arcade, along with the metalwork structure and wooden decking. It was a great loss to the borough coffers, with the estimated value of the loss in the region of £50,000 – a big setback for the local economy in post-war years.

Perhaps the biggest project of the early 1960s was the enclosure of the north Marine Lake and the beach to the lake's west (beach) side. This was due to the sea still retreating from the beach. Where there was sand was now marsh with grass growing there. This was ideal for birds, as all the Ribble Estuary is today, but easier on which to build an embankment. A new (Marine) road would be built on top of this enclosure embankment from the north (Crossens) end to link with the extant Marine Parade Road from the promenade alongside the pier, then south past Pleasureland towards Ainsdale and Formby, using the road built on the former Cheshire Lines Railway track through the sandhills.

The pier was found to be in dire condition due to excess rusting, which was put down to a lack of funding earlier on. The lack of funding had led to a period without maintenance during the war years. Limited opening of the pier was followed by closure, then detailed survey work and costings for repair to the pier and the bridge carrying the Marine Parade over the lake on the north side. This situation led to many thinking the pier would be demolished, which it ultimately was, along with its extension to the jetty platform for steamers to moor, which had stopped in 1923. But at least it was rebuilt to its 1,200 yard length again. Not only did we get the pier rebuilt and reopened just into the new millennium, we got a bonus – a tram – which would run along the pier.

A new theatre was built at the north end of the Floral Hall and opened by no less a person than the great film actress Marlene Dietrich in 1973. The former Cheshire Lines Railway track was incorporated in a new foreshore road running south through the sandhills towards Ainsdale. The south foreshore gardens were now a major strolling area,

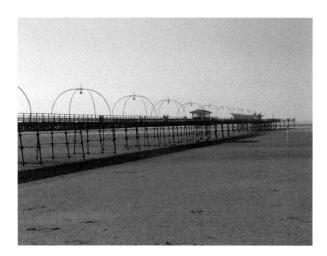

Southport Pier – a view from North Beach.

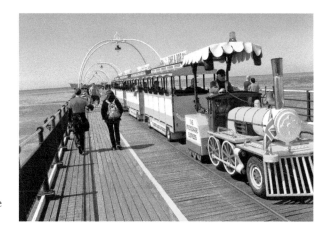

The road train now runs along the pier, replacing the tram.

with facilities for various games such as a putting green as well as open areas for picnics, plus the boating lake with its rowboats.

Lack of maintenance also led to a need for an upgrade to the sea bathing lake, which required a huge amount of money in the 1990s even for temporary repairs. Demolition of the swimming baths was the cheaper option, and sadly this was the final outcome.

The major scheme now in the pipeline was for development of the foreshore at the following areas: the north side of the pier where the open-air pool used to be on the beach, along with the children's sands and play areas; to the south side of the pier where the circular open air-pool used to be, along with the open space of Prince's Park. It was here that the new project was to be built – the Ocean Plaza development. It was estimated to cost £35 million and was given its first planning approval in 1999.

The area to the north side of the pier would contain mainly large retail store outlets. To the south side of the pier there would be a cinema, hotel, shopping mall, sports centre, pub and car parks. This would leave around a third of the size of the original Prince's Park retained as a grassed area from the new Ocean Plaza development area to Pleasureland.

6. Buildings, Memorials and Architecture

A wide-ranging subject such as this, in a town as famous as Southport for its Victorian and Edwardian architecture, is, to say the least, daunting. It is a subject that has been written about by other authors. Perhaps we should start with the buildings we regularly pass. How often do we pass some interesting feature only to pause and say to oneself 'I'll look up what that is' or 'I'll find out about that one day', but we never do 'look up' or 'find out' do we?

Here we shall start another imaginary walk; this time at the Manchester Road end of Lord Street. From here we will walk down the street towards Duke Street and Lord Street West, then on to the Esplanade and alongside the Kings Gardens towards the pier and Floral Hall, as far as the former hospital on North Shore. We can then return to Lord Street having done a fairly long loop. We will look at some of the wonderful buildings from over 150 years ago, built because the architect or owner was keen on a particular type of architecture. We will see examples of classical styles that we have here, as well as appreciate the skills and abilities of the architect and builders in creating examples of buildings comparable to people living in Greek or Roman times.

Lord Street has such a wide range of building to look at: flats, private houses, service buildings, commercial buildings, theatres, railway stations, hotels, supermarkets, and not forgetting the churches and council buildings. But what of the 1960s buildings with the brutish and multi-windowed façades that are still to be seen in the street? At least their presence enables us to compare the beauty of the classical building styles to the post-modern 1960s look.

Although there is a wide range of building types to see on a walk down Lord Street, there are some problems en route. The first is caused by the street described as a 'tree-lined boulevard'. The old saying 'You can't see the wood for the trees' is certainly applicable here, if you replace 'wood' with 'buildings'. If it is not the trees getting in the way of the view, it is the shop canopies above the windows of the shops.

Above: Lord Street Gardens.

Right: Mermaid fountain,
Lord Street Gardens.

In some cases, to see a specific feature above a shop on the west side of the street, you must view it from across the road on the east side, where the gardens are or vice versa.

Aside from the brick and stonework prevalent along Lord Street, we must include the large amount of cast ironwork there is to see from the canopies and their supports – mostly to the west side of the street. These canopies extend for a good half a mile along the street, interrupted only by a building, side street or alleyway. The iron columns

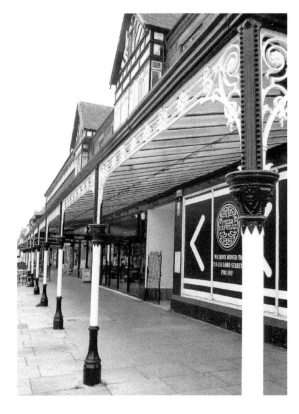

Lord Street shopfronts.

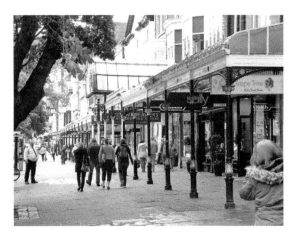

Cast-iron columns on Lord Street.

supporting the canopies are hollow and act as pipes to carry rainwater away from the canopy gutters. Many of the support columns had integral flower baskets, which became overgrown with grass and weeds along with the gutters. In some cases it was as wet under the canopies as it was outside. In recent times – from around the early 1980s – some of these columns have had to be replaced due to internal blocking and/or rusting. In many cases the canopies themselves had also deteriorated over time and required replacing.

The glory and dryness of the canopied walkways along the street became a thing of the past, mainly due to maintenance costs and the replacement of rusted ironwork. The deterioration of the canopies led to a neglected appearance to some parts of the street. The original canopy glazing support bars were of a curved form. This shape gave a greater aesthetic effect, visually. Replacement work saw flat roofs instead of the original curved-glass ones installed on some canopies. This work is ongoing, with some canopies still in need of repair. The canopies are an attractive feature of the street, especially to the window shopper on rainy days. They can also be found in streets adjoining and parallel to Lord Street.

An interesting fact about the columns is that despite their original age (they were built between the 1860s and the late nineteenth century) some have been replaced. In several examples the new cast-iron columns have a different external decoration. Another point of interest relating to the cast ironwork in such abundance here, is that it was mainly cast in Scotland. It is possible to find the maker's name at the base of some of the support columns, such as 'Steven and Co. Glasgow', 'George Smith and Co., Glasgow' and 'Falkirk Iron Company, Falkirk'. There is a local iron founder's name mentioned too – the firm of 'J. Monk of Preston'.

While on the subject of cast iron, on Lord Street's west side there are two major arcades that are a shopper's delights. The first of the arcades is halfway down the street and is today called the Wayfarers Arcade. It was originally the Leyland Arcade when it was built

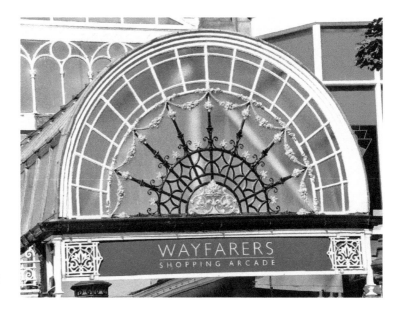

Entrance canopy of Wayfarers Arcade.

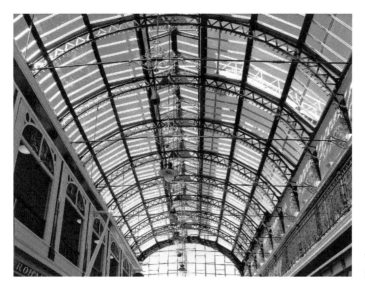

Wayfarers Arcade's inner hall.

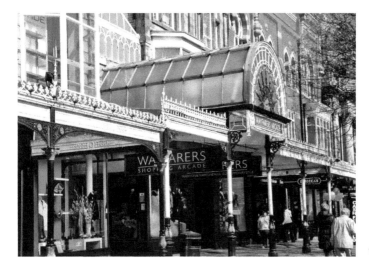

Wayfarers Arcade.

in 1898, named after an MP of the time. Its name was changed in the 1950s to the Burton Arcade, which remained until 1976 when it was given its present name.

Inside the arcade, you will be greeted by large shop windows on each side as you walk along a tessellated floor. Then, above your head, is the magnificent barrel-shaped roof supported by elegant fretted iron beams – the far end curving away from you. This space is often the venue for concerts and exhibitions, as well as shopping and an all-important café. Once again, we find in records that the iron work was of Scottish manufacture. It was cast by W. Mc Farlane, who worked the Saracen Foundry in Glasgow. While searching for historical information it came to light that this company was one of the leading manufacturers of the time, producing cast-iron work of a decorative type. Their work being exported to many places around the world.

The second arcade on Lord Street's west side is the Royal Arcade. It is located towards the south end of the street. Although not as ornate perhaps as the one described above, it still has a canopy and archway with its name in stained glass to the roadside end of its entrance. Plus the arcade allows one to enter a rather magnificent building. We have an entrance passage with shop windows each side, opening out into an area that is now a shop within a shop, it seems. The main business here is one of interest to collectors and purchasers of unusual or antique furniture – a place one can spend some time within just browsing. This arcade does not have the same curved roof as the Wayfarers, but its collector features are a must to browse among and enjoy.

On the opposite (east) side of the street, within the large building with the clock tower, is the Cambridge Hall, which has another arcade. We have no ironwork to see here but we do have many fairly small shops selling all manner of tasteful goods; there is even a small bar now, which always seems popular when I've passed a few times. One of the passages within this arcade has a door giving access into the library and/or the Cambridge Hall complex itself.

We started our imaginary walk down Lord Street at the Manchester Road end of the street, then continued along our first set of canopies to Seabank Road. Our first building

Cambridge Hall clock face.

Cambridge Hall tower statue,
south-east corner.

Cambridge Hall tower statue,
south-west corner.

of note currently has a wooden horse, which looks like the type of work created by collecting driftwood. The building on the corner is called the Bold Hotel. The building dates from 1832, being one of the earliest buildings in the street. When built, it was pub called the Bold Arms. It has a little history attached to it too: the first landlord was a man named John Halfey, who had been at William Sutton's original Royal Hotel, known as the South Port Hotel in the 1790s.

As we continue towards Bold Street, across Lord Street are private houses still retaining the original long gardens. These were a feature that, despite the majority of these having been removed, allowed the street to retain its public garden areas in front of the buildings to become a 'boulevard'. It is intersected by the crossroads of London Street to the east and Nevill Street to the west. At the London Street side of Lord Street, the end was widened after the removal of gardens to create London Square during the mid-nineteenth century.

The centre of this square was used originally as a place where wheeled chairs, horse-drawn gigs and carriages were for hire. Later it became a stop for horse trams, then the electric trams later on. This traffic ran around a central cabin that served as a waiting room and office. Following the end of the First World War, and to commemorate the loss of local men, a memorial was built in 1923 centred on London Square. This war memorial took the form of a central obelisk. At each side of the Square are separate, matching pavilions in which the names of those lost in both world wars are now.

Close to the cenotaph in London Square, on the corner of London Street and a narrow slip road called St Georges Place, is an imposing former bank building. One look at this building conveys its abundant classical features, along with its balanced frontage of window openings and roof gablets. The building started life as early as 1892 by a company

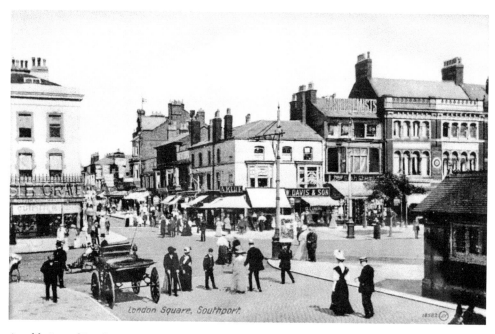

An old view of London Square.

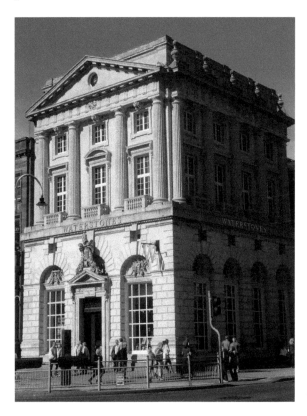

Lord Street, former bank now
Waterstones bookshop.

called Parrs Banking Co. that was based in Warrington. The year 1918 saw its name changed to London County, Westminster & Parr's Bank. It started as the Westminster Bank in 1923, then finally became the National Westminster in 1970. Other than a change to its ground-floor windows, the frontage remains as built.

The building next door to the left was formerly Southport's General Post Office, where I can confirm that in April 2017 the former 'coin in the slot' stamp-dispensing machine slots are still on the front wall.

Looking diagonally across London Square, past the cenotaph obelisk, from the corner of the previous building we see yet another former bank building – white in colour due to Portland stone being used for its construction during 1925–27. This is the former National Provincial Bank, which later amalgamated with Westminster Bank as well as the District Bank. In view of the company now having three banks close together, one had to close; the one chosen was the National Provincial, our choice building, which, no matter where you view it – front, side, top or bottom – there is always some feature on which the eye has to linger. After closure, the building was used for commercial work. The 1980s saw the building changed to a bookshop, which is how it remains today – as a Waterstones store.

The block of buildings that start at Nevill Street with Waterstones, comprise of six or so buildings. This illustrates just about every variation of Victorian architectural exuberance that one may imagine. This row starts and ends with former banks, while in between we

ESTABLISHED
1833

Former bank emblem.

see period architecture dating from the Elizabethan period to the Edwardian – all in one street block. Here is yet another former bank. This was Martin's Bank. Built of red stone (one of two only built with this material in Southport). It was built in 1905 as the Bank of Liverpool.

The other red-stone bank was in Eastbank Street – another Martin's Bank, built in 1925. Both of these smaller Martin's Banks closed following the Barclays takeover, with the Lord Street branch closing in 1978 and the Eastbank Street branch in 1988. Next to this red-stone bank we find yet another style of architecture. This building has a balcony at the first floor with a curving decorative arch above the window and doors to access the balcony. At the second floor are two similar arches with windows below, but smaller than the arch below. At the first floor in the corners formed by the arch and supporting circular columns are decorated panels worthy of note.

Moving next door we come to the five-bay frontage of the Albany Building, which has been described as 'an outstanding example of Victorian romantic ornamental architecture which incorporates Early English Gothic stone windows and Tudor half timbered gables'. To see this building is to wonder at its architect's vision. It was built in 1884.

Art gallery building external figure.

Tudor porch on the top floor of the Albany Buildings.

The next building to the Albany is three floors in height with a large bay at the first-floor window. The upper floor has two curved windows below a balustraded parapet with garden urn ends, while in the centre is a gablet with a red terracotta plaque.

Next comes the real 'jewel in the crown' building on Lord Street. The classical Roman-style Midland Bank, originally the Preston Bank. To see this at its best, one has to look at it from the other side of the street. To see a windowless frontage with twin columns each side of the arched entrance door, above which is a small pediment. The twin columns continue upwards and are joined at the top. These support a plain lintel,

above which is a large pediment. Above the centre top of the pediment is a seated statue. Each side of the top pediment is a stone balustrades with a garden urn decoration.

To the outer sides of the twin front columns are plaques, depicting the Preston Coat of Arms with its 'P.P.' (Proud Preston) motto. This building has been described by writers as follows: 'This building is acknowledged as being one of the finest Roman Corinthian buildings in Northern England.'

So having looked at this west side of the street it's a good time to enjoy the buildings partially hidden by the trees across the street. To our left is London Square, with one of its memorial pavilions. The whole of this memorial, consisting of an obelisk and duel pavilions within a garden setting, is one of the best such memorials in the country. It was built after public subscription amounting to almost £32,000. Also, above the trees to the left, we may see the spire of St George's Church. Turning to face forward, Christ Church is to the right, which had a spire until the 1950s. The interior of this church is now rebuilt, but its function rooms and café are worthwhile visiting to see how a modern interior fits so well into an old building. The tower still retains its bells.

Next to the church is a passageway leading to Chapel Street, where the railway station is located. The building to the right of this passage is Southport Town Hall. Next to the town hall is the massive bulk of the Cambridge Hall with its theatre, art gallery and library complex, plus a shopping arcade.

The former Preston Bank, referred to as the Roman Bank, is famed for its architectural features.

Former bank recessed panel ceiling.

The architecture here is varied, along with its carved-stone panels and statuary. The library is at the right-hand end of this block at the corner of Eastbank Street. This building was once yet another bank. It started life as the Southport & West Lancashire Bank in 1879. It later became the Manchester and Liverpool District Bank in 1884. After closure the bank was eventually incorporated into the art gallery building, with a library created in the old bank.

After our look across the street to the gardens and buildings partially hidden, we can return to our walk down Lord Street under the canopies above the shopfronts. In fact we only need to look at the building next to the 'Roman bank', as many people speak of. The next building is one that is quite an enigma. Its architectural features are distinctly Moorish or Eastern in origin. This is based on the shape of the windows, for they are arched like a horseshoe. Another giveaway is the use of alternate colours of stone in courses. There are some interesting brick patterns below the roof balustrade. The roof at one time had an onion-shaped dome, which has since been removed.

Moving along, we pass the entrance to Wayfarers Arcade, previously discussed. The variation of building styles continues, with more timber-framed, classical or decorative buildings here such as the 'Old Bank', as it is called today. Its frontage, flanked by columns, looks like the entrance to a Greek temple. This building was another bank – the National Westminster, and later the District Bank.

Moorish architecture.

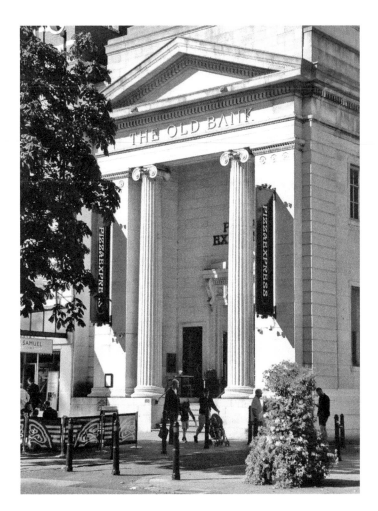

The 'Old Bank'
Greek-style frontage.

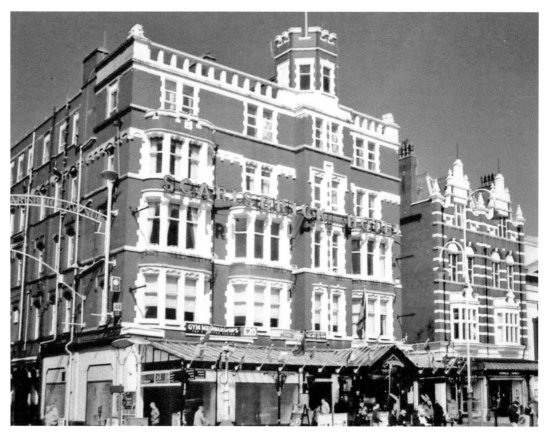

Scarisbrick Hotel fontage.

Next door again we pass the Scarisbrick Hotel, another building that can really only be appreciated from across the street, where we see the Prince of Wales Hotel also.

The next building of note is a Tudor-styled timber-framed building that has recently been restored. The three-floor building has had a period of neglect and alterations, as well as many changes of tenants. This led to a deterioration of the building until the 1970s when the town conservation officer began a campaign to have the building fully restored.

Across the street are the Municipal Gardens, which have also undergone improvements over the past few years. They now include a new bandstand, café, fountain and a large open area where performances and displays are held.

The next buildings of note as we approach the south end of Lord Street are the Royal Buildings with its arcade and the Pavilion building with its interesting wall plaque. We then arrive at what was latterly the Garrick Theatre (which opened in 1932). It was built on the site of the Opera House of 1891 and burned down in 1929. The Garrick hosted many famous personalities and had a 1,200-seat auditorium. It became a cinema in the late 1940s called the Essoldo, becoming a bingo hall in the 1960s.

Adjoining the theatre is a building originally built as part of the Cheshire Lines Extension Railway. This was the entrance to the terminal station and closed in the 1960s.

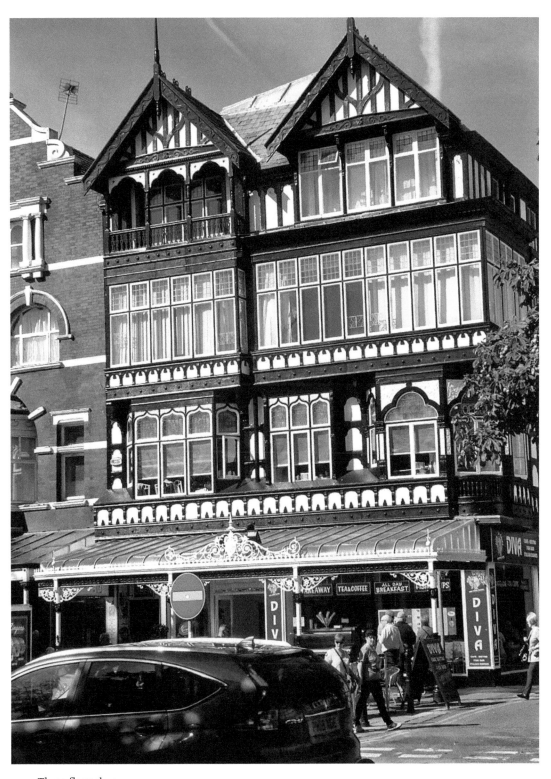

Three-floor shop.

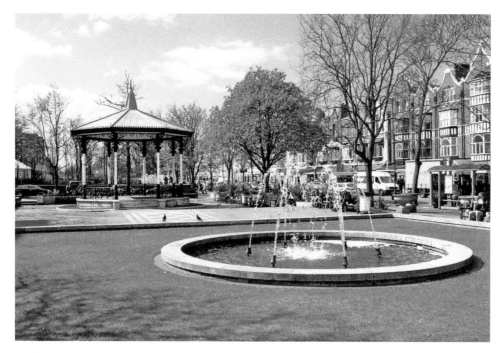

Lord Street Gardens.

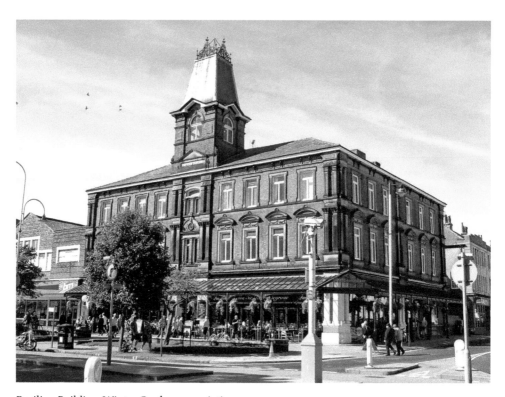

Pavilion Building, Winter Gardens association.

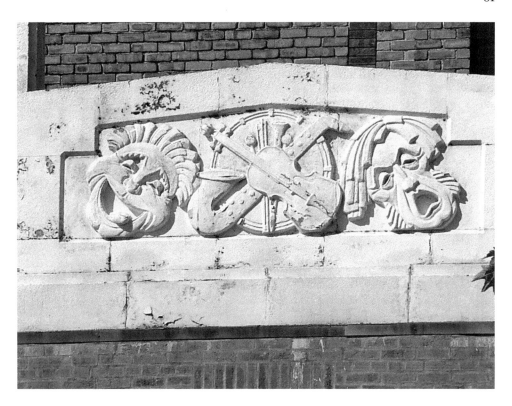

Above: Former Garrrick Theatre, external wall panel.

Right: Former Garrick Theatre art deco window.

Close to this site was the former Winter Gardens Building. The site eventually became Morrisons, whose building style reflects a similarity to the Winter Gardens. As a reminder of the past history of the site, an interesting mural has been painted and mounted above the inner porch entrance to the store.

The former railway offices with clock tower, at the Lord Street entrance to the former station have now been refurbished and reoccupied.

Close to the last shops of the street is a rare Victorian post box; not many of these are to be found today. Note the footpath tiling here too; many tiles still have the manufacturer's brand name of 'Adamantine' on them. Look out for other such tiles.

Here now at the end of this famous Lord Street we are at the site of the founding building for the town in the 1790s, referred to as Duke's folly; a commemorative plaque can be found in the wall at the end of Duke Street relating to this founding. We have previously 'visited' Duke Street to see the former chapel here.

From the end of Lord Street we turn to the right to proceed to the Esplanade, then to the Promenade. First note the semicircular tower in the front of the Royal Clifton Hotel. This building was originally the Royal Hotel, to which the licence from the first hotel built by the Duke was transferred to when the old Duke's folly hotel was demolished.

To the seaward side of the promenade are the Kings Gardens, with attractions such as bowling greens and the Marine Lake. Alongside the gardens is a memorial relating to the

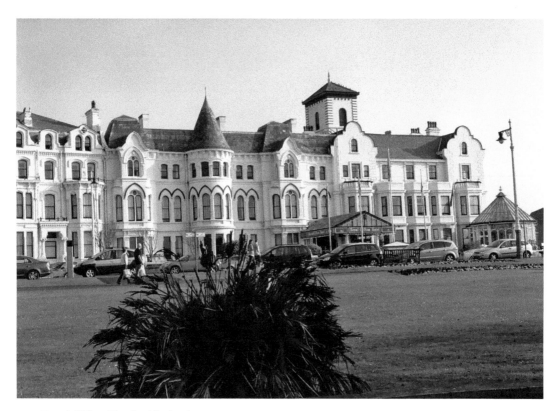

Royal Clifton Hotel, with circular tower.

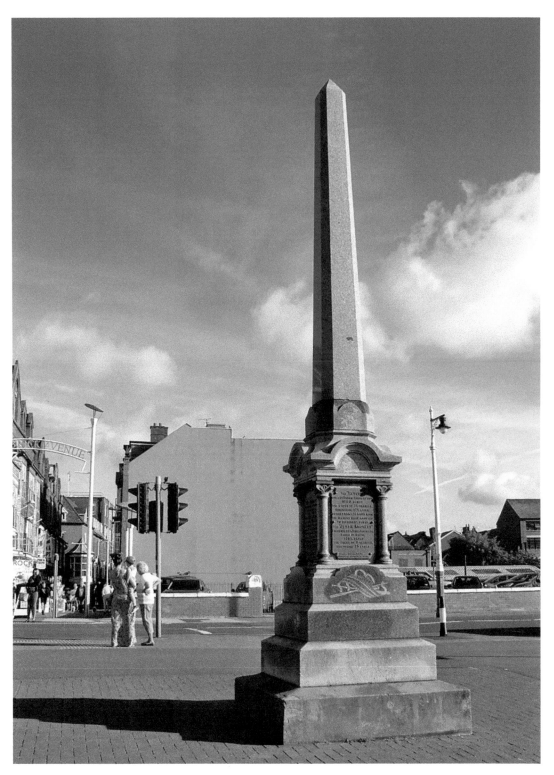

Lifeboatmen Memorial on the Promenade.

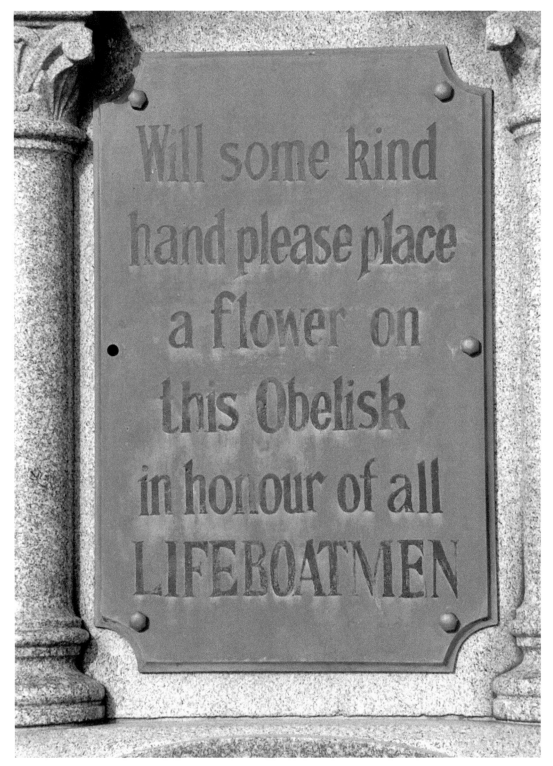

Will some kind hand please place a flower on this Obelisk in honour of all LIFEBOATMEN

Lifeboatmen Memorial plaque.

loss of life of the town's lifeboat men in the *Mexico* tragedy in 1886. The St Annes lifeboat crew were all lost and there were just two survivors from the Southport crew.

Close by is an interesting donated water fountain, and there are some good examples of Victorian stained-glass windows in the refurbished Kings Gardens Tea Room, before arriving at the pier entrance.

The pier entrance may or may not be passed on this occasion in order to arrive at the recently built Marine Way Drive and its superb new bridge over the Marine Lake,

Victorian stained-glass panels in café.

which was has been rebuilt following its closure and demolition in 1997. The Marine Way Parade now leads to the new complex of Ocean Plaza, a project that has seen the area of the foreshore totally redeveloped at both sides of the Marine Way Drive. The site now incorporates a cinema, hotel, gym and many large retail outlets.

Returning to the Promenade again, opposite is the Victoria Baths, now sadly looking well past its best with an overkill of advertising material – much of it hanging off the building. The building seems well overdue for some TLC and refurbishment. Alongside the baths building in Nevill Street we have the statue of Queen Victoria, herself facing down the street towards Lord Street. The war memorial in London Square is also visible from here at the Promenade end of Nevill Street.

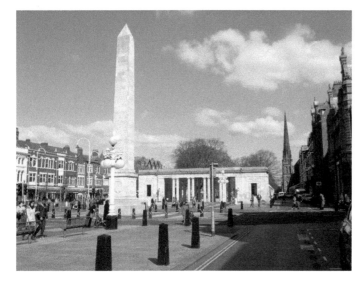

London Square and memorial obelisk base.

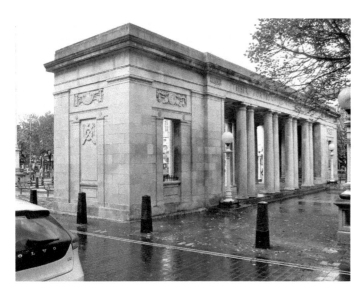

London Square, north side memorial pavilion.

We pass the new complex of the Remada Hotel, built on the site of the former Floral Hall Gardens where we used to sit in deckchairs enjoying a concert or some other entertainment. The old art deco Floral Hall adjoins the hotel and is still entered via the Promenade doors. Attached to the north end of the hall is the Southport Theatre complex, which seems to have 'swallowed' the old hall, which, incidentally, still retains some of its art deco design features.

Beyond this building we continue along the Promenade by the North Marine Lake. Our last building to see and appreciate is to the right, recognised by its French chateau-style towers and singular position at the north end of the Promenade. This is the former Promenade Hospital of 1854. It began life as the Strangers Charity, a dispensary for the poor and sick, which had in Lord Street in 1823. It moved to larger premises in Seabank Road in 1853 and its name became Convalescent Hospital and Sea Bathing Infirmary in 1862. This part of the complex is located to the south side of the site adjoining Seabank Road.

Looking at the south-west corner of the buildings, the earliest portion is to the right-hand side. The larger three-storey portion with the French towers and stepped gables form an extension built between 1880 and 1883, costing £30,000. The charity name

Former Promenade Hospital, west front.

stated it was set up for 'strangers' from all other areas who were in need of treatment, not specifically for local people.

The new extension was built to take care of people from the cotton manufacturing areas in other Lancashire towns. The hospital was taken over by the military authorities during both world wars until 1948, when it became part of the NHS. It was closed in 1990 following hospital reorganisation and the building of a new hospital at Blowick. The building was empty for some time, with considerations to demolish it being discussed. There were many schemes put forward officially and by the public. Many suggestions related to the building becoming a hotel complex.

Many local and district historians and conservationists plus organisations aware of the quality of the buildings with their distinguishing architectural features objected to the proposed demolition. Fortunately, after some years, the building was saved. It was converted to apartments, which were – and still are – highly sought after.

Returning to Lord Street, one may take the route to pass by St Marie's Church to complete an interesting, and perhaps revealing, look at some of the features we hardly even see despite walking past them. There are still many other sites to see and secrets to learn about here. Consider the town gardens and parks, the areas of Churchtown, Birkdale and Ainsdale. Here, too, are some good architectural features to appreciate and wonder about.

7. A Brief Miscellany

To end our notes on *Secret Southport* it would be remiss if I did not refer to the golfing heritage, especially when we consider the number or famous courses there are in the vicinity. And last, but by no means least, we come to the stories of the men – often having little or no mention – who in the past gave their lives to help rescue others from ships wrecked off the shores of Southport. Stories that can never be told; so many secrets lost, and plenty more to be found.

The offshore coast from the estuary of the River Ribble, south towards Crosby and the Mersey Estuary, as well as the offshore sandbanks, have long been a major hazard to shipping, especially during the times of sail when winds forced many a vessel onto shifting sandbanks. Hundreds of ships have been destroyed off this coastline and a great number of persons drowned – crew members, passengers or lifeboatmen themselves. On the other hand, many have been saved by the lifeboatmen. The first known lifeboat was based at Formby from 1776 'to assist vessel in distress'. This was financed by Liverpool's port authority. It may well have been one of the first lifeboat stations in the country.

During the eighteenth and nineteenth centuries the rescue of ships aground or in danger was undertaken by local fishermen as no lifeboat crews existed. The first paid-for boat was financed by local subscription in 1816, but the boat was found to be unsuitable and was withdrawn. A second vessel was built and purchased again by local funds in 1840. It was aptly named *Rescue*.

But it is the terrible wreck of the ship *Mexico* that is uppermost in people's minds when the lifeboat is spoken of. This vessel went aground in a bad storm with force-seven gale as she was leaving Liverpool, and was driven onto a sandbank. Lifeboats were sent from Lytham (*The Charles Biggs*), St Annes (the *Laura Janet*) and the Southport boat (*Eliza Fernley*). It was the Lytham boat that successfully rescued the *Mexico* crew. Due to mountainous seas the St Annes boat overturned with the loss of all her crew. The Southport boat overturned too, with only two men being saved. The St Annes boat was washed ashore on Ainsdale Beach, with three bodies underneath the upturned boat. In total twenty-seven men died that fateful night. This is still the highest number of deaths to lifeboatmen on any rescue mission throughout the whole country.

Of the Southport fishermen we have little information, other than the few odd references to the numbers of boats by the pier end – either anchored or tied up. As well as early mention of them setting up a community at the Nile Estuary in the 1790s, there are records of fishermen drowning in official reports and newspapers.

The first vehicles, other than the horse-drawn carriages, in Southport were the trams that were introduced in 1863. These were four-wheel, double-deck, open-topped cars pulled by a pair of horses. The original line ran from Churchtown to Birkdale via Lord Street and was very basic. An electric operating system was introduced in 1900 after

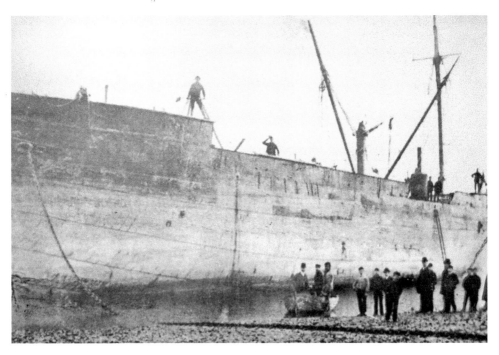

Mexico wreck on beach.

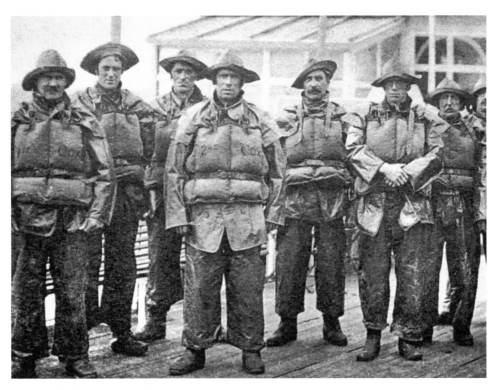

Group of lifeboatmen in uniforms.

Silver Bullet.

the track had been relaid with heavier gauge rails. The electric cables were laid below the existing trackbed. For new routes, overhead wiring was erected, but the system was phased out by 1930.

The trams were superseded later by buses after a trial period when a 1906 bus hired from the Vulcan Motor and Engineering Company at Crossens in 1924 was trialled. In 1926, the route was extended as the bus proved popular with passengers. Southport Bus Sub Committee was asked by the bus manufacturers in Leyland to purchase buses from them, but the Vulcan supplied buses were preferred and seven single-deck buses were obtained after 1925. This was the year that saw a regular service route from Lord Street to Ainsdale. The first double-deck buses were Leyland-built Titan TD1's in 1929.

Of the motorcar, this was on the scene here in the early 1900s, with Vulcan manufacturing these from 1902–29. Buses and lorries were also made at this works, whose building is still here today. As can be imagined, many motor vehicles of that time had been made in Crossens. Normal road cars are one thing, but racing cars are another breed. During the 1920s Southport Promenade was found to be suitable for car racing. The wide seaward side of the Promenade footpath was used for the course itself, with spectators watching from the sides. Speed trials took place on the local beaches with many famous

cars and drivers. At least one speed record was broken here. The local 'speed king' was Jack Field, who began racing in 1928 and drove at the famous Brooklands circuit in 1930.

One of Jack's cars, called *Hells Angel*, was bought from Henry Seagrave and fitted with an engine bought from Malcolm Campbell. Then there was the *Silver Bullet*! This car was famous for its speed runs at Daytona Beach, Florida, USA. It was driven by Kaye Don in 1930, who was attempting to beat Malcolm Campbell's record speed of 217 mph. The car returned to England and was bought by Jack Field and paraded through the streets. The car was 31 feet long and weighed 3 tons. It had two in-line 12-cylinder engines. Apparently if it did not start the first time it flooded and all twenty-four spark plugs had to be cleaned.

Another former Malcolm Campbell car that was in Southport for a time was his Sunbeam V-12, which Jack Field hoped to win the Southport Flying Mile competition with. This car was sold to an aspiring Bill Cotton who became a popular band leader, himself involved with this type of auto sprinting.

I refer in passing to the original beach buggy called a Sand Yacht, which was driven on Southport beaches during the early 1900s; it was a boat with a sail and wheels.

Southport features in some interesting flying events, which, like the previous subjects, appear not to have been written about very much. Yet the beach at Birkdale was being used in 1909 when aeroplanes were first being introduced. There is also a reference to a hanger being established in Crossens in 1910 with another at Blowick. The earliest flyer I have come across who spent some time in and around Southport is named Claude Grahame-White, described as being a 'famous aviator of the time' in 1911. He was visiting Southport to take part in one of the well-promoted Flying Circus events that were held at the then suburb of Blowick, north-west of the town. His usual aeroplane was a light two-wing plane into which he sat in the open without a cockpit. The postcard I have shows a very smart Grahame-White sitting in his pilot seat dressed in a suit wearing a bow tie and a flat cap. Blowick was also the place where air races were held around a circuit.

From 1919 the first pleasure flights began from the beach. The following year Norman and Percy Giroux formed the Giro Aviation Company, which became a well-established company lasting well into the 1960s. Norman Giroux became an RAF squadron leader in the war years.

When reading up on trams and buses, I discovered mention of a hanger adjacent to other hangers nearby, with one being used to accommodate three Giro Aviation Co. biplanes. This was allegedly 'somewhere off Hesketh Road'.

The beach was still being used for local pleasure flights during the 1950s when I had my very first flight in one of the biplanes, which lasted around fifteen minutes circling the town and returning back to the beach from over the sea. The take-off and landing site was close to Pleasureland. The Giro Company must have still been running things at this time. For a trip across to the neighbouring Blackpool in the earlier days, passengers were given a certificate to say they had flown at over 1,000 feet.

Today we have an annual air show – best viewed from the beach – when all types of aircraft participate and display. A few years ago one of the 'stars' of the show was the flypast of the last Vulcan Bomber with its delta wings and camouflage paint work. Today the Red Arrows are regular visitors.

Secret lion at large. Where is it?

I bid 'good hunting' to you as you look around Southport and try to visit some of the places I have mentioned, as well as those I have not, such as the parks and gardens. Good luck and thank you for reading about the town we all care so much about.

Bibliography

Sefton Libraries Sand and Sea, various author contributors (2012).

E. Bland, *Annals of Southport* (1903).

P. Mayer and G. Openshaw, *Southport, A Portrait in Old Picture Post Cards* (1989).

P. Aughton, *North Meols and Southport* (1988).

G. Wright, *Southport a Century Ago* (1992).

G. Wright, *Southport 200 Years* (1992).

G. A and A. G. Burgess, *Southport Through the Letter Box* (1990).

R. and M. Freethy, *The Wakes Resorts.*

C. Greenwood, *Thatch Towers and Colonnades* (1990).

I. Simpson, *Southport* (1996).

F. Bamford, *Back to the Sea* (2001).

F. Frith, *Around Southport* (2000).

J. Graham-Campbell, *The Viking World* (1980).

J. Campbell, *The Anglo-Saxons* (1982).

A. Sieveking, The Cave Artists (1979).

J. Smith, *Southport* (1995).

J. Smith, *Southport Through Time* (2012).

Acknowledgements

I would like to acknowledge the help and co-operation of the following authorities, organisations and individuals who have assisted me in the research and progression of *Secret Southport*. Also, thanks go to the many past and present authors and postcard producers whose works I have studied, noted and extracted information from, or whose images I have used to produce this work. Quotations used are based on original documents or from other works, and slightly changed as per context.

First and foremost my thanks to Sefton Council Leisure Services Department (Libraries), via Southport Library Service, for research in the reference library and permission to use the following publication with the proviso of acknowledgement to Sefton Council Publications.

To the joint authors of the Sefton Libraries Publication of *Sand and Sea* following the Formby Conference of 2004 (which I attended) – many of the contributors I know personally such as Jen Lewis, Annie Worsley, Sarah-Jane Farr, Rob Philpott, Ron Cowell, Gordon Roberts, Barbara and Reg Yorke. The publication has recalled a good conference and my own shortage of notes! Also thanks go to staff at Southport Town Hall for access to the building and advice.

To the proprietors of many shops/arcades in and around Lord Street for access and/or permission to view or photograph property details. To Messrs Morrisons Supermarkets, market stallholders and certain locations within the Ocean Plaza complex for access and photography. Also to the proprietors of Kings Garden's Tea Room for access and information. Not forgetting *Southport Visitor* newspaper for historical information.

To the following individuals for help and anecdotes: M. Duffy, Mrs D. Firgarth, G. Isaacs, Mrs M. Holland, Mrs T. Holden and B. Holding, and Mr G. Wright. Also to Mr Gordon Walker of LMS. Locomotives (2012) Ltd for information.

A special thank you to Barbara Morgan, whose help and advice, along with computer know-how, has assisted me in the completion of this book.

Thank you all so very much.

Jack Smith,
June 2017

About the Author

Jack Smith has been a regular visitor to Southport since boyhood in the 1950s and has lived in and around Chorley most of his life. He served an apprenticeship in Heavy Engineering at the former locomotive work at Horwich, near Bolton, and attended the Mechanics' Institute adjoining the works.

After a decade at sea as an Engineer Officer working on passenger liners, cargo ships and a troopship, he returned to shore to work on mill machinery maintenance, moving to the Royal Ordnance Factory in Chorley for twenty years where he was latterly a Quality Assurance Auditor on ammunition production and research.

Jack is involved with various historical and archaeological groups, and sits on the Council for British Archaeology, North West Region's Industrial Archaeology Panel.

He is a board member with Rivington Heritage Trust, formed to ensure the protection and conservation of the former Lord Leverhulme's Terraced Gardens at Rivington near Chorley, Lancashire. He is a Programme Organiser for the BAe Warton Railway, Transport and Industrial Archaeology Society.

Jack is also a member of two U3A groups and was the founder – now president – of the Chorley Historical and Archaeological Society. He is currently engaged on a personal two-part history, plus an Apprenticeship Autobiography of the former Horwich Locomotive Works. Jack has produced other books for Amberley Publishing.

Queen Victoria looks towards London Square.